THE ROADRUNNER

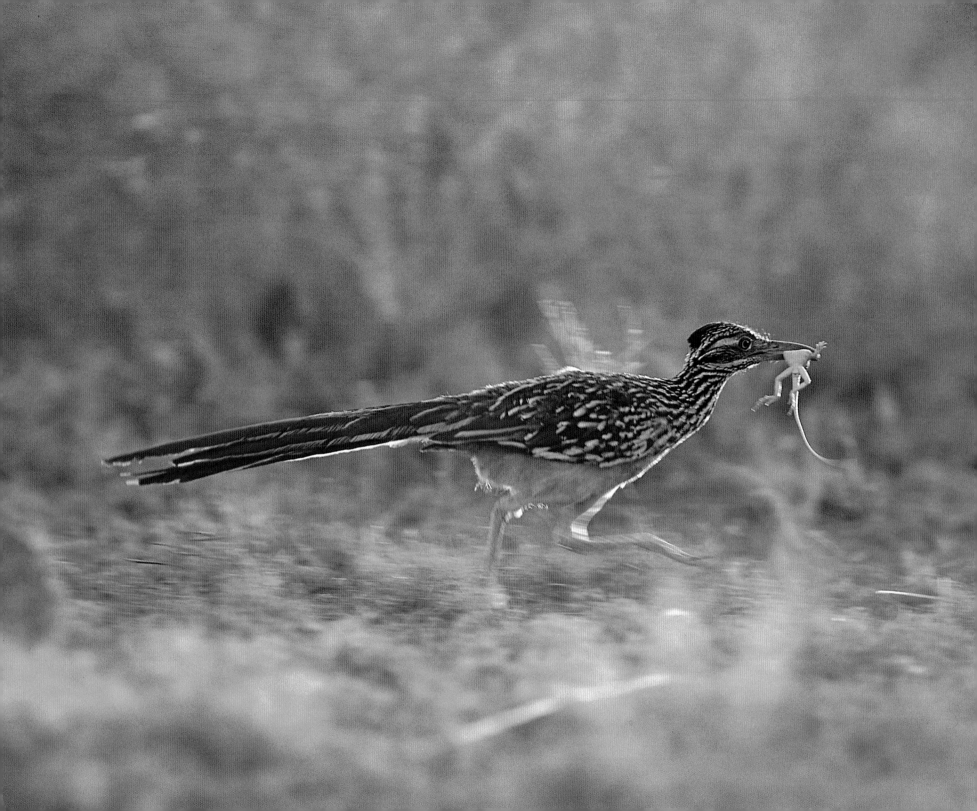

THE ROADRUNNER

WYMAN MEINZER

TEXAS TECH UNIVERSITY PRESS

This book was set in 11 on 16 Palatino and printed on acid-free paper that meets the guidelines for permanence and durability of the Committee on Production Guidelines for Book Longevity of the Council of Library Resources. ∞

Design by Dwain Kelley

Printed and manufactured in Hong Kong by Everbest Printing Company

Library of Congress Cataloging-in-Publication Data
Meinzer, Wyman.
 The roadrunner / Wyman Meinzer.
 p. cm.
 ISBN 0–89672–243–0 (cloth : acid-free paper). — ISBN
0–89672–244–9 (paper : acid-free paper)
 1. Roadrunner. I. Title.
QL696.C83M45 1993
598'.74—dc20 92–33693
 CIP

93 94 95 96 97 98 99 00 01 02 / 10 9 8 7 6 5 4 3 2 1

Texas Tech University Press
Lubbock, Texas 79409-1037 USA

DEDICATION

To my sons Hunter and Pate, whose innocent curiosity keeps me attuned to our natural world. And to Sarah, my wife and critic, whose ideas and support played a major role in making this book possible.

PREFACE

The idea for this book came almost by accident when a friend and old college classmate, Larry Butler, phoned me one day for a casual visit. During the conversation, the subject drifted to work and I mentioned that I had spent several months over a span of years photographing and studying roadrunners. Almost as an afterthought Larry said, "why don't you do a book on the roadrunner?"

My interest in nature began long before that phone call, even before I seriously became interested in becoming a professional photographer and author. It began when my brother and I were young boys exploring the mesquite thickets and badlands in the Rolling Plains of northern Texas. Our explorations were, at the time, inquisitive probes into a land rich in wildlife. But such an environment has a way of molding those who frequent it. We were no exception. Our wonderings led to indepth questions concerning the pulse beat of our wild lands, and years added a degree of maturity that destined me to a lifelong list of questions that only the wild ones can answer. Such was the basis for this book.

Many have asked "but why the roadrunner?" The rangelands of the United States offer a diversity of interesting subjects to photograph or direct our intellectual energies. And a number of species deserve to be the central theme of a book. But when one considers the criteria to be "the chosen one," the roadrunner wins hands down. In the thirty-five odd years that I can recall observing wildlife, no one creature has a personality to equal that of the chaparral. Quarrelsome, funny, serious, playful, fearless, and caring: all of these words describe some aspect of a roadrunner's personality during the course of a day. Many creatures display some of these characteristics at one time or another, but the roadrunner seems to carry it all to a new level. To say that the roadrunner has a singular personality is an understatement. To understand why I choose to document the lifeways of the roadrunner is to know them.

The years spent working with the roadrunners were some of the most intensive times of my life. Through the summer heat or cold rains of autumn I must admit that I enjoyed our times together immensely. But like any toil of love , there were moments of hardships and disappointments. Nesting pairs were few and far between. A nest in 1978 was the first and last one I saw

until the summer of 1982. Then, I was told of another nest in 1984. Although I spent much time to locate another, it was six years before I found another nest. Finally, in 1991, I located a bonanza of three nests. I spent countless hours trying to befriend the wary birds. I failed most of the time. Eventually, one pair accepted my presence, or perhaps my intrusion, and they became part of my family. I like to think that perhaps I became part of theirs. There were times when I felt the sorrow and loss that one feels when someone close dies. Such as the time a trusting female and her nestlings fell prey to a marauding raccoon. The only thing I found to show that she existed was a handful of tail feathers. Each time I see photos of her in my files I feel a tinge of sadness.

My little feathered cuckoo friends are responsible for teaching me much about life and death struggles that occur each day throughout the lands of our world. During the time spent with the roadrunners, I saw reptiles run or crawl for their lives only to meet death head on in the form of feathers and stabbing beak. I saw roadrunners face the deadly stare of a rattlesnake, often killing the reptile only after dodging its repeated strikes. I have observed the adult birds spend weeks caring and tirelessly feeding the young, only to see the fledglings die within moments after leaving the nest. The adults never stopped for a moment. They simply continued to nurture the living young that still offered continuity for the species. Even when my own emotions immobilized my observations for a time, the adults carried on.

This book has been an effort of love as much as a scientific contribution. I feel that I owe it to these fascinating birds to give, in an interesting and artistic form, the true story of the roadrunner in their natural world. Although I feel a loss when searching for words that will convey my knowledge of this interesting bird, I hope that this collection of thoughts, memories, facts, and photos, will somehow do justice to an indescribably fascinating bird. To those families of roadrunners who befriended me, I hope that my endeavors were not in vain.

ACKNOWLEDGMENTS

My heartfelt thanks goes out to a multitude of people for their contribution in the creation of this book. My photographic work required many weeks afield each year. I could not have covered the geographic area that was necessary to get the shots I did for this book without the help of ranchers, farmers, carpenters, oil field employees, and kin. All are my friends and to each I extend my sincere gratitude. Without these willing and thoughtful individuals I could not have offered the contents of this book in the depth and artistic form that is needed to convey the special moments that I shared with my roadrunner friends.

Without the fledgling idea of Larry Butler, I may never have launched into this joyful project. To Dub and Jo Cartwright, Mr. and Mrs. Philip Bruggerman, Mr. and Mrs. Mat Verhalen, and Clara and Jack Brown, I extend a special thanks for their willingness to contact me about nesting roadrunners around their homes and to allow me access to the paisano families. To Bob Moorhouse and my brother Rick, I am indebted for keeping a watchful vigil throughout their travels in the brush for nesting chaparrals. Because of a shared appreciation for my roadrunner friends, I could not have gained as much of the insight into their habits without the total cooperation and limitless help of Vernon and Edgar Jones and Trina, Ken, and Jason.

The support and inspiration of my dear friend Betty Bisbee was an inspiration for me in my attempts to convey my thoughts and observations in a meaningful manner. To all of my former professors in the Range and Wildlife and Biology departments at Texas Tech University, I am indebted for their instilling in me the concept of professional observation during my memorable years under their direction. To the staff at the Texas Tech University Press, especially Carole Young, I extend my heartfelt thanks for believing in this book idea and for making its publication possible. And finally, in memory of the late Royce Speck, my sincere thanks for his sharing of information that led to some of the most dynamic photos and information for all to see.

THE ROADRUNNER

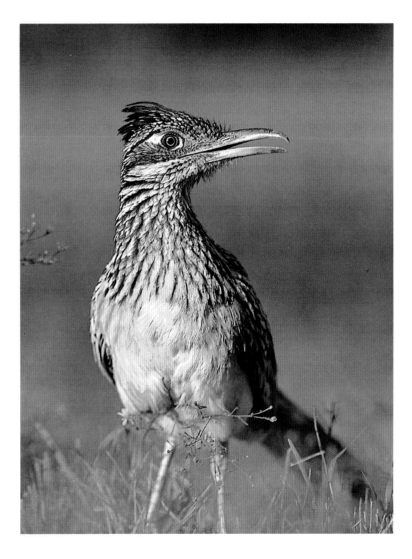

Birds have been a source of inspiration for mankind throughout history. Studied by early inventors whose dreams included man soaring the skies alongside avian counterparts and revered by shamen who believed that by partaking of the flesh of certain birds one could gain strength or prowess, birds have fascinated and intrigued man across the centuries.

Perhaps no single species of bird has enjoyed more widespread popularity and mystique than the greater roadrunner, *Geococcyx californianus*. Because of its hunting antics, physical characteristics, and general attitude toward life itself, many names have been coined and applied to this bird. In Texas it is often refered to as the chaparral or chaparral cock; in New Mexico, lizard-eater or snake-eater; and in Mexico, paisano (compatriot or fellow countryman), or *corre camino* (runs the road). The roadrunner has been the subject of mythology and folklore for centuries. Even today, its personality and antics are projected to millions in the form of cartoon characters on worldwide television. Probably no creature more frequently symbolizes the southwestern United States than the roadrunner.

The roadrunner has not always been revered by all. The efficiency with which this bird dispatches large

numbers of insects and reptiles led some people to consider the roadrunner as a probable predator on quail populations. Many people shot roadrunners on sight and at one time placed a bounty on all that could be killed. Further research proved that the roadrunner does not prey on quail as was once thought and persecution of this bird has halted. The roadrunner is now protected under federal and state law.

DESCRIPTION

The roadrunner is built for speed with long legs and a sleek body. The bird's entire length is about twenty-four inches, half of which is tail feathers. Both male and females have a buff-colored underside with a mixture of black, bronze, and buff feathers on the breast. The back and tail are black and white with blue, green, and bronze iridescence. Both sexes have a crest on top of the head and an iridescent patch of skin behind each eye. While adult roadrunners are resting or cruising a daily pattern, the head crest is not conspicuous, but when their curiosity is aroused, the black and bronze green crest feathers are raised and lowered constantly. Many times, I wondered about the gender of the birds hunting about the area, but I found it difficult to discern if a specific color scheme was specific to either sex. Some believe that the patch of skin located behind the eyes may be the key to identifying the sex of the individual, but my observations have proven that both sexes have identical eye patches with identical color schemes. The skin in this area is white, blue, and the last one-third bright orange. When the birds become excited or angered, the coloration of this skin becomes even more obvious. If obliged to say that a difference really exists, I might suggest that this orange section of skin was a bit brighter on the male.

Whether walking slowly on a casual stroll or engaged in a hunting foray, the stride of the adult roadrunner is six to eight inches. When the bird is running, its gait stretches to a ground-eating nineteen to twenty inches.

The roadrunner is one of the few members of the cuckoo family with a terrestrial lifestyle. Like all members of the cuckoo family, the roadrunner's feet are zygodactyl—that is, two toes point forward and two point backward. Unlike most members of this family it is not a parasitic nester, although I have observed an instance of a communal nest.

4

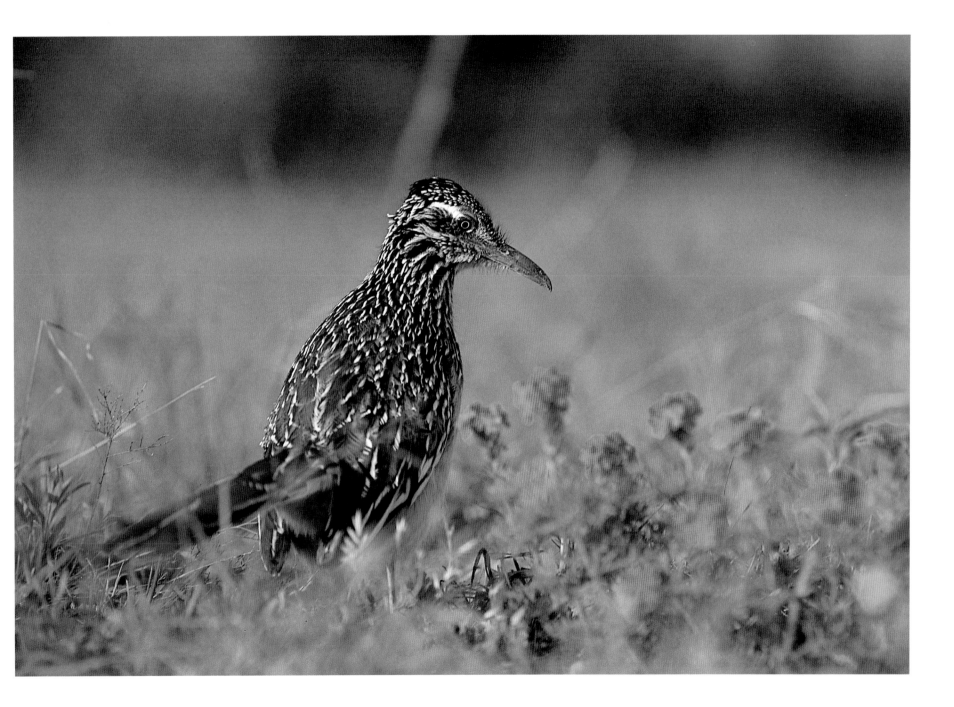

When the roadrunner might have appeared in relation to the geologic timetable is not exactly known. Some believe that approximately ten thousand years ago the roadrunner took to the ground as a descendant of tropical cuckoos that fed on easily accessible insects and fruits, and over time, flight became nonessential. Others contend that the paisano made its initial appearance during the Pleistocene more than one million years ago and has been racing with lizards ever since.

DISTRIBUTION

The range of the roadrunner extends across the southwestern United States including southeastern Colorado, southern Kansas, and across central Oklahoma and south into central Mexico as far as Puebla. These birds are found at elevations ranging from sea level on the Pacific coast of Mexico, California, and the Mexican Gulf Coast beyond Tampico to altitudes of seventy-five hundred feet in the inland mountains of its range. In West Texas, New Mexico, and Arizona, the roadrunner often appears in valleys below five thousand feet, especially in the region east of the Rio Grande. A sighting in 1907 recorded a roadrunner was found near Marshall Pass in Colorado at an elevation of ten thousand feet. It is doubtful that these birds breed at their extreme northernmost ranges. With the possible exception of those elevations above five thousand feet, the roadrunner thrives over almost all of New Mexico and Arizona. In Texas, the primary region for the chaparral is the western portion of the state, including the Big Bend region along the Rio Grande, south along the river to Brownsville. Its range extends northward up to the Texas Panhandle and east across the Rolling Plains to the east-central part of the state.

Within its home range, the habitat that the roadrunner occupies is usually quite diverse. In north-central Texas, where I have observed the chaparral for over thirty-five years, the birds have no preference for any particular type of habitat, although the region is varied in both topography and vegetation. In the Rolling Plains, which are dominated by mesquite and lotebush on the deep-soil escarpment areas and extremely broken badlands with an overstory of juniper, agarito, and sumac, the cooing melody of the roadrunner can be heard throughout the spring and summer. In the Panhandle region of the state, the favorable habitat lies in the ranching areas that

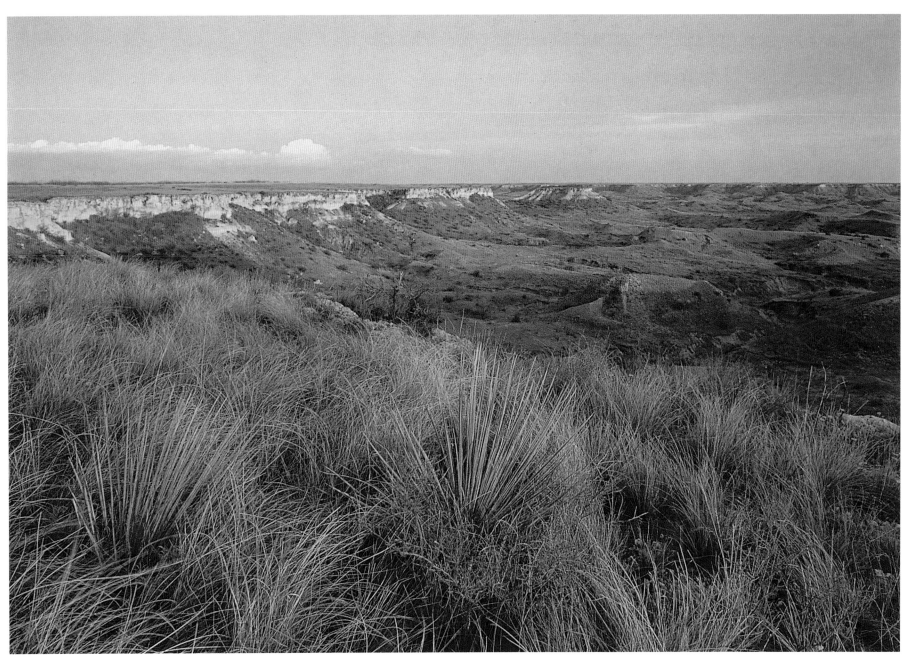

The habitat for the roadrunner within its wide range is varied. This is the yucca and shortgrass region of the plains of Texas.

are scattered within extensively cultivated locations. Around the escarpment of the Llano Estacado, or "caprock" region, the roadrunner is found in substantial numbers. In the Trans-Pecos region of Texas, the paisano chases grasshoppers, lizards, and rodents through the ocotillo and greasewood-covered landscape.

In New Mexico, Arizona, and southern California, roadrunners occur in abundance along the southern extremes of the states. In a land given to a desert environment, the chaparral is able to survive well among the paloverde, catclaw, ironwood, agave, cactus, mesquite, and ocotillo.

HISTORY

Wildlife has always played a significant role in the culture of Native American peoples. Long before the twentieth century the chaparral was a bird of intrigue for many Native American tribes. Both hunting and farming cultures used a variety of species of the local fauna in ritualistic activities ranging from planting the annual crops to totems for battle and war. The most notable of these tribes were the Pueblo Indians, artisans of the Southwest, whose religious beliefs and legends encompassed more than one hundred species of fauna that coexisted in the southwestern environment. These people were avid bird watchers and held the roadrunner in high regard. Community life revolved around various species of birds that they considered spiritual intermediaries or messengers between men and gods or between man and man.

In the Pueblo culture, the roadrunner is a bird of great magic. In part this reputation was gained because their tracks in sand or dust may be confusing. Because two toes point forward and two backward, it can be difficult to determine the direction the bird is going. One belief of the Pueblo is that a safe afterlife for the deceased can be ensured by placing roadrunner tracks around the house of the dead. This will confuse the evil spirits as to the direction taken by the spirit of the dead. To the Pueblo, the roadrunner symbolizes strength and endurance. The bird's willingness to fight the rattlesnake is regarded as a feat of bravery and because of this has a role in rituals dealing with courage.

The Tarahumare Indians of the Sierra Madre, perhaps the fleetest runners in the world, hunted the roadrunner for its flesh. They believed that by eating the meat of

this bird they would be endowed with great speed and endurance. Certain tribes of the Great Plains believed that hanging the skin of the roadrunner over the lodge door was good luck and would keep bad spirits away from the inhabitants.

Archaeological sites show that the roadrunner played a role in the lives of the plains Indian tribes in Texas. On a sandstone cliff along the escarpment of the Llano Estacado, centuries-old petroglyphs depict scenes of the daily life of the Comanche Indians. Among the scenes of battles and death is the unmistakable image of a roadrunner. What capacity this bird played in the life of this particular band of Indians we may never know.

Even in the societies of the English-speaking people of the southwest no other bird captures the imagination more than the roadrunner. So much has this bird held the fascination of the people through the centuries, it is of no surprise that folklore has elevated this bird to unparalleled heights. Called war bird by various Indian societies, snake-eater, medicine bird, and cock of the desert, whatever name one chooses to call this fascinating bird, it is without doubt the roadrunner has made and will continue to make an indelible impression on all people who choose to observe this cuckoo of the southwest.

HABITS AND BIOLOGY

I grew up on a ranch in the badlands of north Texas. When we were children, my brother and I encountered a variety of wildlife as we scoured the ravines and mesquite flats for cattle throughout the spring and summer seasons. Unlike many

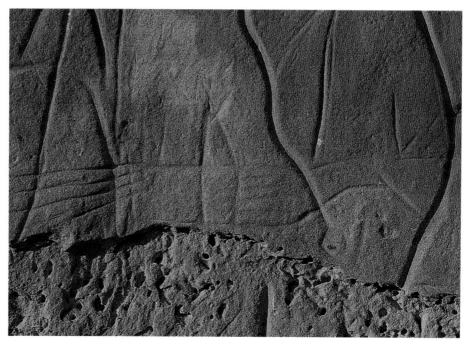

Petroglyph of a roadrunner found along the edge of the caprock in Texas.

9

youngsters raised on ranches, I regarded wildlife observation as a definite priority over cattle work and spent almost all of my leisure time in the brush. Whether I went on foot or horseback, I looked for dens or nests of the many species of wildlife that thrived in the hills along the Brazos River. A routine walk through the mesquite and juniper could yield the nest of the Mississippi kite, redtail hawk, and mourning dove.

If my friends and I wanted to find a variety of reptiles, then our travels took us into the desolate badlands. Here, the American collared, Texas spiney, and greater earless lizards could be found darting across the rocky landscape. But if the roadrunner was our goal of the day, we had to look no farther than the backyard of our home. Here, the darting forms of several roadrunners could be seen at almost any time chasing the spotted whiptail lizards that used our old rock fence for a home. It always intrigued me to watch the chaparral on a hot summer day as it sat under the mesquite tree near the barn panting away the blistering days of July and August.

Along the caliche roads and cow trails, we often ran our horses or drove our vehicles to the working areas on the ranch. Many times, we passed fence posts with a lone chaparral sitting atop, perhaps watching for insect or lizard activity in the tabosa grass below. As we passed the roost the roadrunner often would leap from its perch, volplane to the ground, and race alongside the horse or vehicle in an apparent challenge to our intrusion. I have never measured the speed of these birds but there are numerous mentions in literature about attempts to accurately measure the speed that the roadrunner can achieve. H. H. Sheldon wrote of an incident that occurred early in the 1900s when he was able to clock a running paisano with the aid of an automobile: "The car gained on the bird until about five yards separated us, and I saw it was running at its utmost speed. I instructed my friend, who was driving, not to press him further, and for fully three hundred yards the bird ran from the big monster in pursuit, the while the speedometer registered exactly fifteen miles per hour."

As a young boy of perhaps fourteen, I was afflicted with a misdirected inspiration to try and chase down a roadrunner. A friend and I had seen frequently a juvenile bird cruising down a fencerow inside an old field. One hot, June day we observed the movements of this unsuspecting paisano and immediately gave pursuit. Within a few minutes, both bird and boys were exhausted. When we were almost ready to give up the

chase, the confused chaparral darted into a tangle of vines, and we captured it. After a few minutes of inspecting our captive, we released it none the worse for the wear. It was my last attempt at running down a roadrunner!

The roadrunner has evolved into an incredibly adaptable creature, as seen in its ability to conserve body energy during critically cold periods by controlling its body temperature. Roadrunners are nonmigratory. During cold weather, the birds roost in dense trees or shrubs that shield them from the open sky and night winds. Unless incubating on the nest, they save body fuel by lowering their core temperature from about 101 degrees to 94 degrees fahrenheit during the night. However, the roadrunner's morning sunning ritual is probably the most critical factor in energy conservation.

Anyone who has lived in paisano country has observed, at one time or another, a roadrunner standing in the early morning sunlight, usually on the east side of a brush thicket, with its back to the sun, wings partially extended, and feathers ruffled to expose the skin on its back. Adult birds retain the black-pigmented skin of the nestling bird in this area of the body. The soft, black,

downy feathers located around the pigmented area also absorb heat, but more importantly form a layer over the black skin that prevents heat loss when the bird is sunning. The roadrunner maintains this sunning position throughout the cool hours of the morning. The bird begins to hunt only when the ground temperature is adequate to allow reptiles and insects to become active. Although sunning occurs in many species of birds, it is thought that none equals the roadrunner in the efficient use of solar energy.

A behavioral pattern that I noted only once while observing nesting activities in July 1991 could possibly reveal another temperature regulation behavior. It occurred when daytime temperatures were nearing one hundred degrees fahrenheit. In late July I had been observing a pair of roadrunners hard at work capturing locusts for their brood of four juveniles. At approximately ten o'clock in the morning the male hopped onto the tires of a nearby plow and exposed his back to the glaring mid-summer sun. Unlike the partially expanded wing stance usually used by sunning roadrunners, the bird extended its wings almost fully while bowing its head underneath his body. This occurred for a duration of perhaps three minutes before he jumped from the

perch and continued to hunt. Within fifteen minutes he again stopped in the bright sunlight and maintained this exact position for another two to three minutes. Normally such activity would be described as solar absorption but with the ground temperature nearing a sweltering one hundred degrees fahrenheit and the fact that the bird was panting heavily during this period, I believe that this activity may be connected with the release of excessive body heat.

Two of the most interesting aspects of the roadrunner's behavior are its curiosity and its acceptance of human activity within its home range. Roadrunners were quite common around our home in the badlands especially in spring and summer. Many times when I sat in the yard, I watched a paisano trotting around seemingly oblivious to my presence. On one occasion, I happened to have a camera with me and tried to photograph a bird that almost seemed to want to get into my lap. The roadrunner finally came so close that I couldn't focus on him, and even felt some concern that he might try to peck the front lens element. In retrospect, I believe that the bird may have seen its reflection on the lens element and was curious as to who the tiny look alike might be.

Virginia Douglas noted in her interesting book *Roadrunner!* that when they were clearing brush and rocks on their Arizona property, several roadrunners consistantly stopped by to watch the excavation work. Finally, one young female befriended them and became an almost daily fixture on the property. "We noticed a young female, sleek, trim and full of life, who came up behind us as we worked, announcing her presence with a loud clacking—a sound similar to castanets. In the open, switching her long tail from side to side and shuffling her feet, she seemed to delight in startling us. Her crest shot up and down, showing off her blue and white colors in addition to a gorgeous deep red, which is why we named her Ruby."

We never named the paisanos that came to our home because we never knew which ones were new additions or old customers. Whether new or old friends, however, they ate dog scraps, stood on top of the ranch vehicles, and chased whiptail lizards throughout the spring and summer. One day, my mother mentioned that she kept hearing the sound of something hitting the window above the air conditioner. She thought one of the roadrunners might be creating the disturbance. The next time the window pane began to rattle, I walked outside.

Roadruners will nest around barns and are often seen sitting on an elevated perch. The perches are never higher than what the bird can reach by one hop and a flap.

Sure enough, on top of the air conditioner stood the ruffled aggressor squaring off for another attack on the intruder in the window. During the ensuing days, I observed that same bird attacking our truck window as well as the exterior rearview mirror! This bird had claimed our yard and driveway as its territory and was actively defending its right to the area. Martha A. Whitson described similar behavior in roadrunners that she observed in the Big Bend region of Texas.

After the long cold winters in the Rolling Plains of Texas, I always wait anxiously for the first signs of spring. In the deep ravines along the Wichita and Brazos rivers, the song of the canyon wren signals the approach of the spring season. As a boy, I would climb through canyon crevices and creek bottoms in search of whatever caught my fancy, and I was forever conscious of the bird songs of the seasons. Each year in the months of February and March, you can sit on the long rims of gypsum canyons and hear the call of the quail, mourning dove, and wren. But heard above the rest is the mournful call of yet another

13

creature. Its *coo—coo—coo* echoes down into the river bottoms, often causing frustration to those who might be unable to identify the source. After a visual search of the rimrock, the source of the cry is discovered in the form of a male roadrunner standing atop a high boulder emitting his mating call in hopes of attracting a receptive mate from somewhere in the badlands below.

After observing and photgraphing roadrunners for a number of years, I can recognize at least sixteen different sounds, including the cooing call emitted during courtship, a whine by the female during nest building, and a *Hummm!* when the adults enter the nest area to feed the fledglings. The auditory display used most frequently by these birds is the clattering sound made when they rapidly pop their upper and lower mandibles together. This sound can be broken into subsounds that are used to locate one another, for anger, and warning signals. During the weeks I spent working with the nesting birds, I often mimicked the clattering sound when I entered the nesting area to alert the adults that their old friend was back, armed with nothing more than cameras and lenses. Interestingly enough, when I had trouble finding the hunting adults, I used the same call to locate the birds; they almost always returned the call or came

to my location. Other sounds observed during the weeks of watching and photographing roadrunners include a barely audible hoot that is also used when adults are anxious about possible danger to the nest. Another call that is used infrequently is a clearly audible clucking call that consists of approximately five to seven evenly spaced clucks. This call is used by both sexes to locate one another. Clucks, whines, and mandible pops are the most frequent types of vocalizations that are heard during food foraging and nest building. On one occasion I watched a male trespass into an area that was not part of the pair's territory. He flew into a low shrub in the new area, stretched his neck parallel with the ground, and emitted a grunting whir.

FOOD HABITS

Old myths and folklore die hard, and the roadrunner has both suffered and benefited from stories of its eating habits that have circulated throughout the century. Early in the twentieth century, it was accepted as fact that chaparrals were predators on a few game bird species, notably quail. At

one time, the federal government placed a bounty on the paisano in a misdirected attempt to save the struggling quail population.

Fortunately, a few interested scientists took an opposite stand on the issue, and in 1916, the University of California issued a pamphlet entitled "Habits and Food of the Roadrunner in California." The researcher, Harold C. Bryant, conducted a food-habit study of the roadrunner and determined that insects comprised 74.93 percent of the stomach contents of eighty-four roadrunners examined. No quail were found, but mice, lizards, baby rabbits, and two unidentified birds were included in the list. A later report issued in 1932 in *Arizona Wildlife* by D. M. Gorsuch of the United States Biological Survey stated that grasshoppers comprised 62 percent of the roadrunner's diet even during the period when quail actually were nesting and leading their young broods into the field. In no cases did remains of any quail, young or old, show up in the stomachs of the one hundred roadrunners sampled.

I have found the paisano to be an opportunistic feeder whose diet reflects the diversity and relative abundance of insects and reptiles in a given area. If the cricket population is high, this is the prey toward which the bird will direct its hunting energies. At one particular nest I observed in 1982, the adult birds became so accustomed to my presence that they tolerated my companionship during their hunting forays into the mesquite thickets. During these runs, over 60 percent of the prey captured and fed to the juveniles was that of the horned lizard *Phrynosoma cornutum*. Numerous spotted whiptail lizards, *Cnemidophorus sacki gularis*, were caught, but the predominant reptilian prey was the horned lizard. Very few crickets or grasshoppers were brought in during this nesting period of late April and May.

On the other hand, in 1984 at a nest located some eighteen miles west of the 1982 nest site, no horned lizards were captured and killed during the days I spent observing and photographing this nest. I even brought a mature horned lizard to the nest site to see if this pair of adults knew how to kill this animal, and was surprised when the adult birds paid little attention to the added tidbit. By far, the main fare for this family of roadrunners consisted of crickets and grasshoppers. The adults had nested late in the breeding season that year, and the fledglings were hatched during the height of a grasshopper infestation.

In part, the roadrunner was respected by various Native American tribes because of its reputation for attacking and killing such a fearsome foe as the rattlesnake. Perhaps the most popular myth about roadrunners is that they will build a corral of thorns around a sleeping rattlesnake. The snake will then impale itself on the ring of spines when it tries to escape. Told this tale since I was old enough to remember, I actually believed it for several years. However, documented accounts of battles between rattlesnakes and roadrunners are rare in the literature. Many of these sightings occurred in the outback regions of old Mexico in the early 1900s when ranch hands happened upon such encounters and watched the deadly outcome.

Because the roadrunners were so accepting of my presence, I realized I had a unique opportunity to embark on an experiment to determine once and for all if this bird would do battle with the venomous opponent. On numerous occasions, I captured rattlesnakes of various sizes and released them in the general area of the birds' hunting territory. Some of the reptiles were large diamondbacks; others were the quick and nasty-tempered but smaller massasauga or pygmy rattler.

With possibly one exception, the adult roadrunners would circle the larger diamondbacks and drop their wings in an apparent test to see if the snake would strike. After circling the snake perhaps two or three times, the birds would go on their way without so much as giving the coiled rattler a second glance.

When the roadrunner encountered the smaller massasauga, however, the spirit and spunk of the feisty roadrunner burned brightly. When the massasauga saw the bird, it would coil in a defensive posture. On every occasion as it did with the diamondback, the roadrunner would crouch low, begin to circle the snake, and drop its wings to test the snake's quickness. As the snake struck, the bird leaped back almost as fast as the eye could follow, then leaped forward, grabbed the rattler by the head, and tossed it into the air. When the snake hit the ground, the bird was upon it instantly, grasping the head and beating it repeatedly upon the ground or more preferrably on a rock or stick. If the snake protected its head underneath the coil, the roadrunner seized the rattler by the body and beat it against the ground until the snake relaxed, exposing its head. After perhaps fifteen minutes of this furious activity, the bird seized the snake and dashed to the nest to feed its fledglings.

Interestingly, all reptiles including horned lizards, whiptails, and nonvenomous snakes were killed in this same manner. From what I observed, the maximum length of a snake that a roadrunner will venture to attack is two feet; the average size is fifteen inches. Roadrunners tend to prey on smaller snakes such as garter snake, small bull snakes, and hog-nosed snakes. The males will attack larger snakes than will females. Occasionally a pair will work together in an attack. In a team attack both birds will circle the prey looking for an opening. The first bird to find an opening will attack and carry through on the attack, while the other bird watches. If a prospective prey resonds aggressively to the roadrunner, no matter what the size, the bird will break off the attack.

In addition to horned lizards and grasshoppers, roadrunners will consume moths, centipedes, scorpions, millipedes, tarantulas, cutworms, spiders, bumblebees, mice, rats, young rabbits, and snakes. Some instances have been reported of the chaparral feeding on vegetative material such as prickly pear apples and sumac berries if pressed by a shortage of more palatable food items. Only once did I see a roadrunner eat fruit. The bird approached a tasajillo cactus and knocked several of the small spiny fruits to the ground. It then tumbled the fruit along the ground for a minute apparently to remove the spines before consuming the fruit.

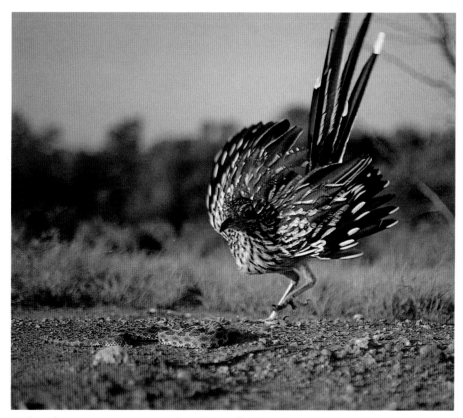

A roadrunner attempts to surprise a diamondback rattlesnake.

17

I have devoted my life—in one way or another—to maintaining close contact with nature. Whether photographing, studying, or simply hiking, I cherish the years spent with the natural fauna and have been richly blessed with memories from the times afield. Yet, few pleasures have equaled the elation I experienced when a family of roadrunners in 1982, accepted me as a friend and allowed me to go with them and witness firsthand the techniques that they used to capture food for themselves and their young.

On a cold, wet day in early March, 1982, I noticed an adult roadrunner carrying a twig in its beak as it traveled toward a clump of juniper trees. I moved quickly to the thicket and saw a nest being constructed approximately nine feet up in one of the trees. In the ensuing days, I kept watch on the nesting activity and noted when the female began to incubate the eggs. Because I did not want her to become alarmed and perhaps abandon the nest, I was careful not to press her with my constant presence. After a few days, I placed a stepladder near the nest and left. Soon, I would stand on the ladder for a few minutes each day, then withdraw. A few days before the hatching of the first egg, I began placing small bits of raw meat on the limb a few feet from the nest before withdrawing. Upon my return, I found she had consumed the tidbits. Soon she began to leave the nest and come to meet me when I climbed the ladder, taking the meat directly out of my fingers. I knew then that a bond had been made.

With cameras ready, I awaited the hatching of the young. Spring in north Texas can be quite unpredictable with extremely cold weather moving into the region with little or no warning. For the first few days after hatching, the female continued to shelter the young with her constant presence. The male, on the other hand, was constantly on the go, bringing grubs and small insects for the tiny "roadsters." Occasionally the adults exchanged places. When relived of her nest duties, the female would stand in the warming sun rays and preen for several minutes. Then she departed into the mesquite thickets and returned within about forty-five minutes with food.

More often than her mate, the female frequently treated herself to a sand bath in an area one hundred yards or so away from the nest. When she returned from a hunting trip, she would approach the old road where vehicle tracks had created a depression in the soft sand. Holding the captured meal for her young—a grub

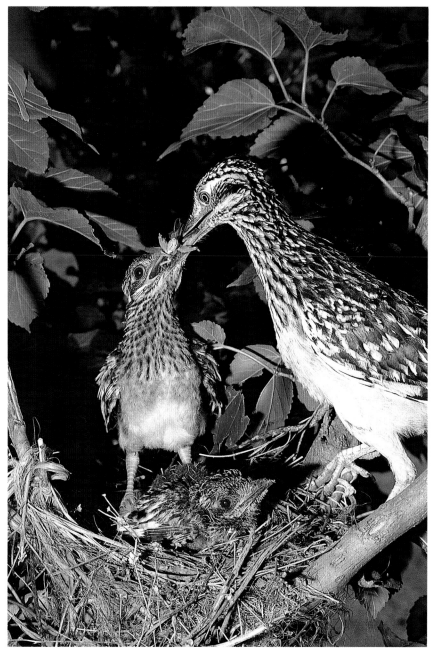

An adult feeds a grasshopper to a juvenile that is ready to leave the nest.

or grasshopper—in her beak, she would lie on her stomach with her beak flat on the ground and scoot along, ruffling her feathers and kicking sand into the air and onto her feathers. Immediately following this activity, she ran to the nest and fed the fledglings. When she entered the nesting tree, the mate always left the nest immediately and headed into the mesquite. She would then feed and brood the young.

After a week to ten days, warmer weather allowed both adults to engage simultaneously in hunting. I decided that perhaps by now they trusted me enough to allow my presence while they hunted.

Before our first outing, I decided I would have to carry a variety of lenses and film, because I had no idea how far the birds ranged during the hunts. Because the average outing took approximately fifteen to forty-five minutes, I wanted to be ready for any unexpected incident during the hunt. As I waited on the ladder, one of adults came trotting around the juniper with a small horned lizard. The bird fed the voracious fledglings and then was on the ground again and running with its new human friend close behind—my chance had come.

Once in the brush, the adult slowed to a deliberate walk, investigating each and every grass clump within

19

sight. Often, while walking through unusually thick grass cover, the bird dropped its wings and took several steps before stopping. I soon learned that this was done to flush insects or lizards from their hiding places.

The main food staple for this nesting pair was horned lizards because the season was too early for the first crop of grasshoppers. During numerous forays into the brush with these roadrunners, I never once saw the quarry before capture was made. One moment the bird would be walking along; the next instant it would dash for a grass clump and pull an unsuspecting horned lizard from its lair. Almost simultaneously, the bird would break into a run and head for the nearest rock or piece of wood. There, it would beat the lizard repeatedly against the rock until the head was bloody and no sign of life was evident. Without further hesitation, the paisano then would run at half speed to the nest and feed the meal to the young.

One incident occurred during a hunt that will remain one of my favorite moments. As I approached the nest one evening, one of adults was standing near a small plank. When I neared the spot, the roadrunner walked around the piece of wood and stopped often to peer under it. I watched for a while before I reached down to turn the plank. As I raised the board, the roadrunner dashed underneath it with a flurry of wings and emerged with a spotted whiptail lizard. The speed at which the capture was made defies imagination.

Two seasons later, I was fortunate enough to be informed of and allowed access to another nest. Here, the adults had grown accustomed to human activity. They were nesting near the home of a family who nurtured the friendship of chaparrals. The nesting pair had incubated late in the season, and their hunting treks coincided with an infestation of grasshoppers. This duo hunted in the same way as the pair of 1982, but few lizards were captured. Almost all of the food that they brought to the nest consisted of grasshoppers, grubs, crickets, and a few small snakes.

The predatory behavior of the roadrunner is well illustrated by the incidents I have described here. Although it appears that these intrepid birds fear virtually nothing except perhaps the largest of the rattlesnakes, one study has reported that at least some roadrunners prefer not to tackle a certain species of horned lizard if another variety of the same species is available. The Texas horned lizard, *Phrynosoma cornutum*, is a heavily armored reptile exhibiting pronounced horns about the head and body.

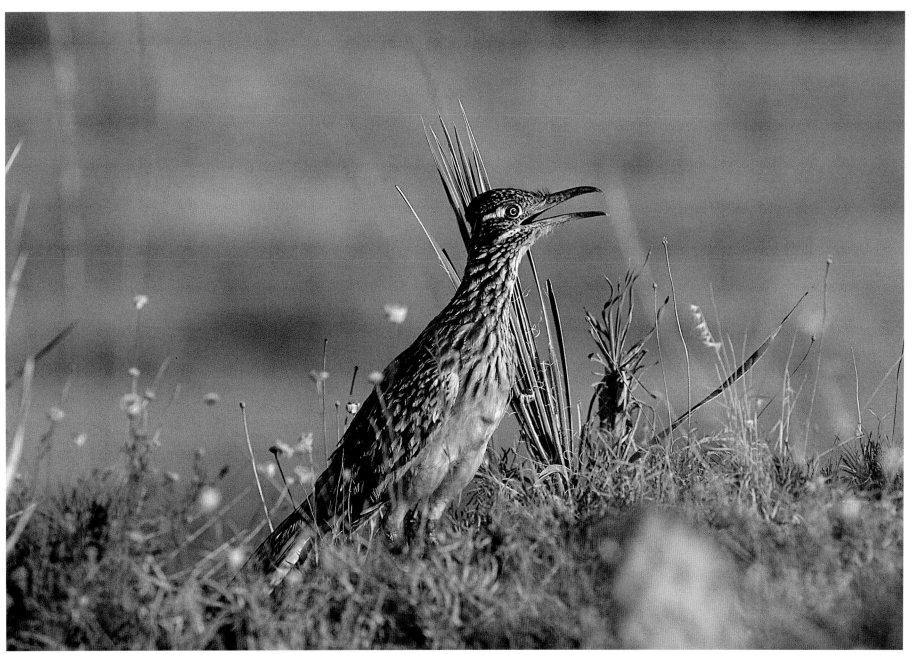

In open country, a roadrunner works its way along the tops of ridges, checks out bushes, and uses small rises or logs as an elevated perch to survey the area.

Phrynosoma modestum, or the round-tailed horned lizard, is a relatively small and defenseless species. Numerous tests conducted under controlled conditions using legally captured roadrunners have shown that the roadrunner captured and killed Texas horned lizards only 50 percent of the time, whereas the round-tailed species was preyed upon 92 percent of the time.

During my informal studies with the wild birds, the Texas horned lizards were the only species available, but I noted on two occasions that the birds did not press their attack on a pair of very large horned lizards. One of the lizards actually initiated a defensive posture and ejected blood from around the eye glands. Both lizards stood their ground when an initial attack was made, arching their bodies and rocking back and forth in an imposing gesture of defiance. The roadrunners did not press the attacks further. On occasion, the birds found and killed rather large horned lizards, but rather than returning with them to the nest, they consumed their kill on the spot and resumed hunting for smaller prey to feed to their young.

One of the most interesting aspects of joining the roadrunners' hunt was the opportunity to see them ingest some of the larger prey that was not taken to the nest-

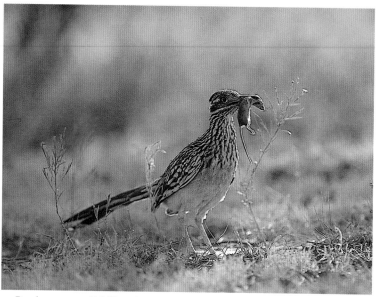
Roadrunners will kill and eat mice.

lings. All of the large horned lizards and snakes were beaten and pecked until the heads were bloody, then were swallowed head first. Even the larger horned lizards were swallowed, seemingly, with relative ease. On one occasion, however, when an adult roadrunner killed a two-foot rat snake, the actual time for the snake to be completely swallowed was several minutes. I can only guess that perhaps the roadrunner must wait for digestive juices to take effect on the already swallowed portion of snake before the remaining length of tail can be completely injested.

During my last season with the roadrunners, I watched them kill a young woodrat and several brush mice. They used the same technique to kill these ani-

mals as they do for reptiles but sometimes had to beat the animal for an hour before it was crushed enough to eat it. In both instances, the birds were engaged in courting or in making their mating calls, and were displaying the rodents as furry offerings of love. Arthur Cleveland Bent remarked that he raised a pair of roadrunners and actually witnessed the birds killing a large rat.

Snake-eater or lizard-eater, two names dubbed this comical cuckoo over the decades are no doubt bestowed with reason.

COURTSHIP

My first intimate encounter with roadrunners occurred in midwinter of 1977 when two adults began to stop by my workshop to pop their beaks and stare through the door with unbounded curiosity. At times, the wind blew so hard from the north and the pair of cuckoos looked so dismal that I felt compelled to find some tidbits to offer them. No matter what I gave them, they consumed it with gusto.

As winter passed and the warm winds of spring settled over the mesquite-covered badlands, this pair of roadrunners became less visible. I could hear the cooing of the male in the brush in his bid to win the approval of the female. The cooing mating call of the roadrunner is a common sound in the spring throughout the Southwest and is often mistaken for the call of a mourning dove. Contrary to previous observations, both male and female emit the cooing courtship call. The male often selects a high vantage point from which to call. A fence post, the rocky rim above a canyon, or even the roof tops of barns and houses are favored spots.

Bowing his head until his bill is thrust between his legs and slowly raising his head upright, the male pours his call across the landscape. Sometimes, he mans his station with an offering for any adoring female passing by. The enticement can be something as small as a twig, but sometimes the more enterprising males offer lizards or mice. With gift held firmly in beak, he continues to call. When a receptive female appears he approaches her with the gift. Wagging his tail back and forth, he continues to emit the call until copulation is enacted. At some point before mating is completed, the female usually snatches the gift from his mouth.

During the five times I observed the mating activities of the adults, a distinct ritual was enacted prior to copu-

lation. Each time the male approached the female with intentions to mate, an offering is brought for display. Not all offerings are accepted by the female and if the offering is not accepted mating will not occur. Twice I saw the male offer locusts or crickets but both times he was rebuffed by the female. Subsequent offerings of spotted whiptail lizards, a wolf spider, and brush mice resulted in the pair mating.

Of some interest is the vocalization that takes place both when the male locates a tidbit that might arouse the attention of a female and when copulation is about to take place. Once, when I was but a few steps away, the male snatched a wolf spider from beneath a shrub. Instead of gulping it down, as had been the case earlier with some locusts, he emitted a throaty purr and quickly ran to the nesting site. The female emitted the mandible popping call and met the male a few yards from the nest. Still purring steadily, the male followed the female to a shaded spot about twenty steps distance. At that time the male initiated the mating ritual and copulation was completed.

Observations by other naturalists indicate that when copulation is complete the female snaps the gift from the mouth of the male. I noted this only one time. A spot-

ted whiptail lizard offered by the male during mating was taken by the female to the nest and fed to one of the juveniles. In four other instances the male did not allow the female to take the gift, which resulted in a fierce tug-of-war that the male won. Afterwards, the female followed the male for a period of time begging in a submissive posture, but the male refused to give in.

From start to finish the courtship ritual of roadrunners is quite predictable. The male approaches the female in short, quick bursts of speed. Holding the offering tightly in his beak he wags his tail back and forth, often leaping high in the air over the female. If the female is receptive, the male lands on her back and initiates copulation. If the female is not receptive she will stay ahead of the male and not allow him to approach her closely. From mounting to the taking of the offering, takes about one minute. When copulation is finished, both birds stalk about one another for perhaps five seconds with heads held high and bobbing slightly. Both birds then either take dust baths or stand nearby and preen for several moments.

My observations indicate that the male and female copulate once for each egg that is laid.

THE YOUNG

One day, my parents noticed some unusual comings and goings of two birds around the old chicken house. Informed of the increased activity, I went out to investigate. There in the top of a ten-foot-tall mesquite tree was a paisanos nest with four large fledglings ready to consume anything that dropped into their oversized mouths. The nest, made almost exclusively of small mesquite twigs, was approximately eighteen to twenty inches in diameter. A shallow nest, it had been made somewhat more comfortable by the addition of grass and pieces of string picked up around the barn. One egg remained unhatched, but I believe this was because the egg was sterile; for many days after the young had left the nest, the egg remained.

The ensuing years have provided me with frequent opportunities to observe juvenile roadrunners through all stages of growth. The plumage of the newly hatched roadrunner is coarse, whitish, and hairlike. Its density is sparse, so that the almost black, leatherlike skin is exposed. Within a few days, blood quills replace the white hair and become somewhat more dense. The feet of the young are huge in relation to their body size, making them appear disproportionate. (Actual feet measurements were not taken on the juveniles, but adult feet measure about three inches from back to front claw.) As juveniles near the time to leave the nest, they bear a likeness to the adults, but still lack the iridescent plumage of their parents. The topknot or crest, which is obvious on the juveniles, is raised and lowered often, especially when adults are close by with a possible meal.

All of the nests I have observed contained from two to five eggs, although instances of as many as twelve eggs in a nest have been recorded. Where large numbers of eggs are found in one nest, it is probable that more than one pair of roadrunners is using the nest. The eggs are chalky white and measure approximately one and a half by one inches. The female lays the eggs at intervals of one to four days, with an incubation period of about eighteen days for each egg.

If the eggs are laid in this sequential manner, the young birds in a nest should display various stages of growth, perhaps with the first juvenile leaving the nest while the youngest bird is only a few days old. These intervals did not appear so pronounced in any of the nests

I observed. If the eggs were laid at intervals, perhaps only one day had elapsed between their laying.

During the incubation period, both adults share the sitting chores. Sometimes the female will perch in a tree within a few yards of the nesting tree when the male is sitting on the nest. The pair will communicate on occasion using the manible pop. Once, both birds used the cooing call normally emitted during courtship.

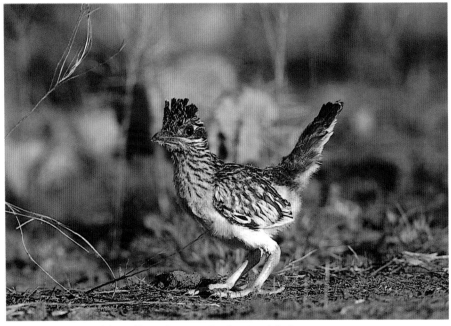

A juvenile roadrunner that has just left the nest.

Adult roadrunners proved to be considerate and protective parents throughout the many months that I spent observing them. When food was brought to the fledglings, the adult always stayed long enough to ensure that the lizard could be safely ingested by the young. On one occasion, the adult brought a rather large horned lizard to the nest and dropped it into a waiting mouth. The juvenile attempted to swallow the over large helping, but failed. The adult finally pulled the lizard from the young bird's mouth and offered it to another. Again, it could not be swallowed. Finally, the adult realized the meal was more than the nestlings could handle swallowed the lizard itself then departed for another hunt.

Juveniles are ready to leave the nest when they are about fourteen to twenty-one days old. A clutch of two to three nestling seems to mature and leave the nest sooner than a larger brood. How quickly these young birds grow is dependent on the volume of food intake. Fewer nestlings to feed means each nestling is fed more frequently by the parents. Also, when four to six young are in the nest, the first four to five juveniles leave the nest rather rapidly, generally a couple of days apart. When one or two young remained in the nest, it ap-

peared that the actual growth rate slowed somewhat because the adults were kept busy feeding the older juveniles that had already left the nest. Fewer trips are made to the nest to feed the last young birds, especially if only one remains, which seems to delay the orderly sequence of departure from the nest. In 1991 I noticed the last young roadrunner in the nest about a week longer than the others. Also, it was evident that the feeding frequency by the adults to the last youngster had dwindled to about half due to the attention given to the juveniles already on the ground.

The juveniles in the l982 nest began leaving the nesting tree approximately twenty-one days after hatching. My first evidence that the young were about to disperse occurred when I noticed them perched on limbs apart from the nest. The following day, the oldest juvenile was on the ground beneath the nesting tree and soon began to move away from the tree at short intervals. The remaining young began to leave within a couple of days after the departure of the most mature fledglings. With each passing day, the young moved farther away from the nest, while the adults patiently continued to feed them at regular intervals. Perhaps three to five days following the juveniles' departure from the nest, they were on their own, although they continued to stay within thick cover where shrubs and trees allowed easy escape from predators.

At one nest each juvenile that left the nest immediately took refuge in a mesquite and tasajillo thicket about ten yards from the nest. After spending two days there they moved to another thicket fifty-seven yards from the nest. On the fifth day they had worked along a protected fence line to another mesquite refuge 120 yards from the nest and continued at this rate for several more days. Although easily located by their audible communications with the adults, the juveniles always retreated deep into the thickest entanglement of limbs when I approached. A second nest of juveniles that I observed in the summer of 1991 displayed a tendency to travel farther from the nest during a short time period. I believe this was because of the scarcity of cover in the immediate vicinity of the nest. By the third day after leaving the nest they were already in excess of two hundred yards from the nesting tree. In this instance I was fortunate to observe the adult coaxing the juveniles from the nesting site, across an expanse of open rangeland, and into a thicket of mesquite. The episode began after the adult brought the youngster a collared lizard to eat.

After the juvenile devoured the lizard, the adult began to emit a muffled purr while standing a few feet from the young bird. The juvenile answered with a purr and advanced a few feet in the direction of the adult. The adult would run several yards and stop and call again. The youngster would follow. The juvenile would often display some misgivings about crossing the open area and balk. Each time the adult would return and repeat the coaxing. Soon the young bird was within the safety of the trees. Interestingly, not once while crossing the danger zone did the juvenile stop and beg for food. However, once inside the mesquite thicket, it frequently ran in front of the adult to display itself, with wings quivering, in hopes of getting a morsel.

When juvenile roadrunners were about to leave the nest for several days of survival training, the adults would appear to be scouting for locations for a new nest. On two occasions I noted this behavior and both times the female would sit in the tree begging in the submissive posture while the male brought her twigs. In both instances the nest building was abandoned after a few twigs were in place.

The population density of roadrunners in the North Texas region seems to be cyclical, much like the popula-

tion cycles of the black-tailed jackrabbit. The population density of the paisano in 1982 was at a level higher than I had seen in previous years. Although 1982 seemed to be a peak year for the numbers of roadrunners in northern Texas, it was not until 1984 that I recorded any evidence of adults raising two clutches within one nesting season. In June of that year, eighteen miles west of my home in Benjamin, Texas, I was informed that a pair of roadrunners was occupying a nest constructed approximately eight feet high in a juniper tree. After I had photographed the brood for about two weeks, the juveniles left the nest for life on their own. The weather was hot and dry, and the area was inundated with an infestation of locusts. Unlike the nesting pair of 1982 whose principal diet consisted of reptiles, this pair subsisted almost entirely on the abundant locusts that thrived in the three-awn and buffalo grasses.

On a hunch, I visited the location again in late August and was surprised to find the same pair raising a second brood in the same nest. One of the adult birds had been working so diligently at killing locusts, lizards, and a few snakes that both its upper and lower beak were broken and worn, a result of the bird's capturing and pecking prey on the hard gypsum rocks so prevalent in

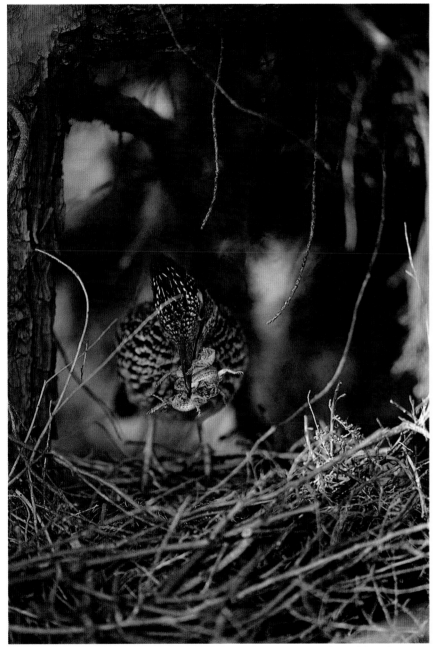

At six days of age, these fledglings are brought young horned lizards to eat.

the region. By late August and early September, the second brood had left the nest. The factors that contributed to the success of this pair of roadrunners in rearing two broods in a season are speculative, but it is possible that the abundant food source and relative ease of capturing prey might have contributed to this successful nesting cycle.

The spring and summer of 1991 was another bumper year for the roadrunner population. Of the three nests that were closely monitored, all three successfully raised three broods of young. A pair of roadrunners located approximately twelve miles north of Benjamin, Texas constructed a nest in a large hackberry tree in April. After raising a brood in this nest, the same pair constructed a second nest some seventy-five yards west of the first nest. The second nest was constructed about fifteen feet high in a mulberry tree. A brood of four young left this nest during the last week of July. One of the young roadrunners was killed by a farmer's dog the day the bird left the nest. As far as I could judge, the remaining three young survived. The adults laid three more eggs during the first week of August in the mulberry-tree nest and successfully reared two of the young. The oldest bird left the nest on September fifth. The second

youngster, in an apparent attempt to leave the nest, was either killed in the descent from the tree or was drowned when rain runoff filled a depression where the bird had fallen. This incident occurred on the seventh. The third juvenile left the nest on September thirteenth.

The second pair that were monitered in 1991 I first observed the two adults copulating on three occasions, 15, 17, and 19 July, while they were still feeding juveniles around the nesting site. On 3, 5, and 7 August, the female laid eggs in the same nest that she and the male had previously produced four young. These three eggs subsequently hatched on 22, 24, and 26 August. The juveniles left the nest in mid-September.

It appears that any roadrunners incubating eggs in late August or early September face risk factors unknown to the broods hatched during the summer season. These birds run an increased risk of food shortage, especially in the more northern reaches of their range. I noted a marked decrease in the density of locust during September. This could be a critical factor in the survival of young roadrunners because these insects are the major food source of juvenile birds. Lack of food could delay the juveniles development, which could prolong their stay in the nest by several days thus exposing them further to mortality factors. Early cold fronts or extended autumn rainfall could increase mortality rates for roadrunners just leaving the nest. This is relative to the summer season when abundant insect numbers and mild weather conditions maximizes the chances of the juveniles survival. I believe that roadrunners do not normally raise three broods in a season but will do so when the food supply is so abundant as to ensure survival of a third brood. The summer of 1991 saw a bumper crop of locust in Knox County and surrounding areas.

Predation on nesting roadrunners seems to be the leading factor in mortality rates among this species. Extremely adverse weather conditions during the winter season takes many adult birds each year, especially in the northern extremes of its ranges. Road kills and predation from raccoons and bobcats probably account for a substantial number of adult individuals annually. In the spring of 1990 I saw evidence of raccoon predation on a nest I had been visiting for several days. Evidence suggested that the adult escaped but at least two of the juveniles were killed and eaten. In 1991 feral cats took two juveniles shortly after they had left the nest near a farmer's house. Also, in the same year, feral cats killed an incubating adult and destroyed the nest within the

city limits of Benjamin, Texas. Once the juveniles leave the nest and attain subadulthood, chances of long term survival seem to rise significantly.

Although past studies have not touched on the territorial behavior of nesting roadrunners, a pair of chaparrals I observed in July of 1991 exhibited strong territorial tendencies during feeding forays. Several days prior to the incident I determined that this pair used an area for food gathering that was roughly eighty-thousand square yards to the south and east of the nest and six-thousand square yards west of the nest. Rarely did the two venture beyond this territory and if they did, it was for only a few yards. On one occasion I was following the male when he ventured about fifty yards outside of their territorial boundaries. Suddenly, without provocation, he wheeled and ran pell mell back onto the range that he normally frequented. A few days later, both male and female were near the southern boundary of the hunting area when a strange adult crossed the territory approximately sixty yards away. The male suddenly snapped to attention and began calling, using the typical coo of the mating season.

Then, in short bursts, he approached the strange bird, flapping his wings once every few steps. The wing beats were very audible and sounded like hitting a mattress with a broom stick. The strange roadrunner began to move away, keeping several yards distance between itself and the angry male. The male continued to push the stranger until it left the premises but did not go further than a few yards beyond his territorial boundary. The stranger stopped approximately sixty yards away and began calling while the male exhibited a great deal of aggressiveness by also calling frequently. The female followed the male to the outer edge of their territory and showed signs of anxiety by popping her mandibles at short intervals. When the male returned to the hunting range both birds seemed to settle down and continued to hunt.

EPILOGUE

As a photographer I have worked closely with various animal species to create images that capture the animal and its relationship with the natural world. Devoting days, weeks, or even months to learn the intimate lifeways of a specific creature and then freeze the sum of that knowledge in the click of a camera shutter is an experience that is difficult for me to convey in mere words.

The time I have spent observing and photographing roadrunners has enriched not only my understanding of these wonderful birds but increased my appreciation for the lives of other wild animals. Through these pages of words and images I hope that the reader will discover the captivating personality of the roadrunner as I have known.

A favorite of folklore and legend, bird of magic, symbol of good luck, and state bird of New Mexico, the roadrunner has a long and colorful history.

FURTHER READING

Bent, Arthur Cleveland. 1948. *Life Histories of North American Cuckoos, Goatsuckers, Hummingbirds, and their Allies*. Dover.

Dobie, J. Frank, Mody C. Bratwright, and Harry H. Ransom, eds. 1980. *In the Shadow of History*. Texas Folklore Soc. Publ. No. 15. Dallas: SMU Press [Reprint of 1939 edition].

Douglas, Virginia. 1984. *Roadrunner! : and his cuckoo cousins*. Naturegraph.

Ohmart, Robert D. 1989. "A Timid Desert Creature," *Natural History*. September.

Omart, Robert D. 1990. "Predatory Behavior of Captive Roadrunners Feeding on Horned Lizards." *Wilson Bulletin*.

Whitson, Martha A. 1983. "The Roadrunner—Clown of the Desert," *National Geographic*.

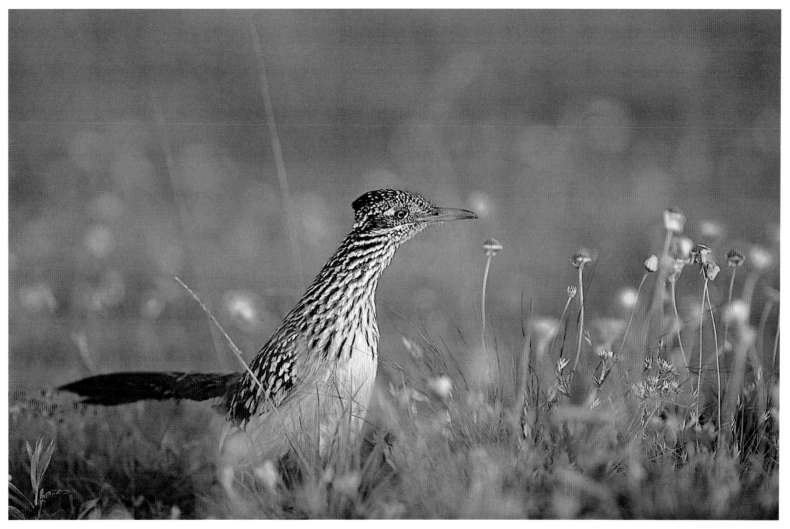

A roadrunner surveys its hunting area.

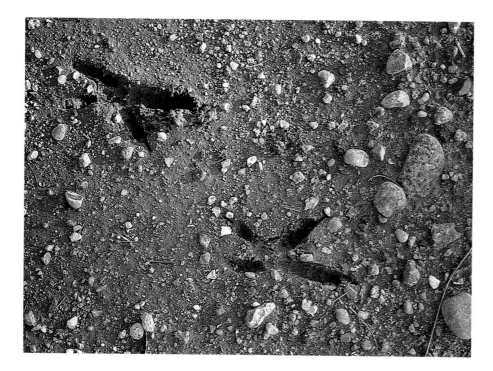

Roadrunner tracks can be confusing because they have zygodactyl feet—two toes point forward and two point backward. Native Americans often drew chaparral tracks around the dwellings of deceased individuals to confuse evil spirits in the afterworld.

Hunting under broomweed for insects.

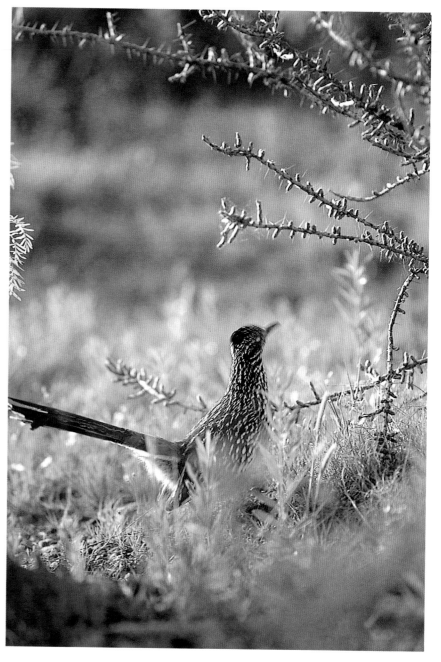

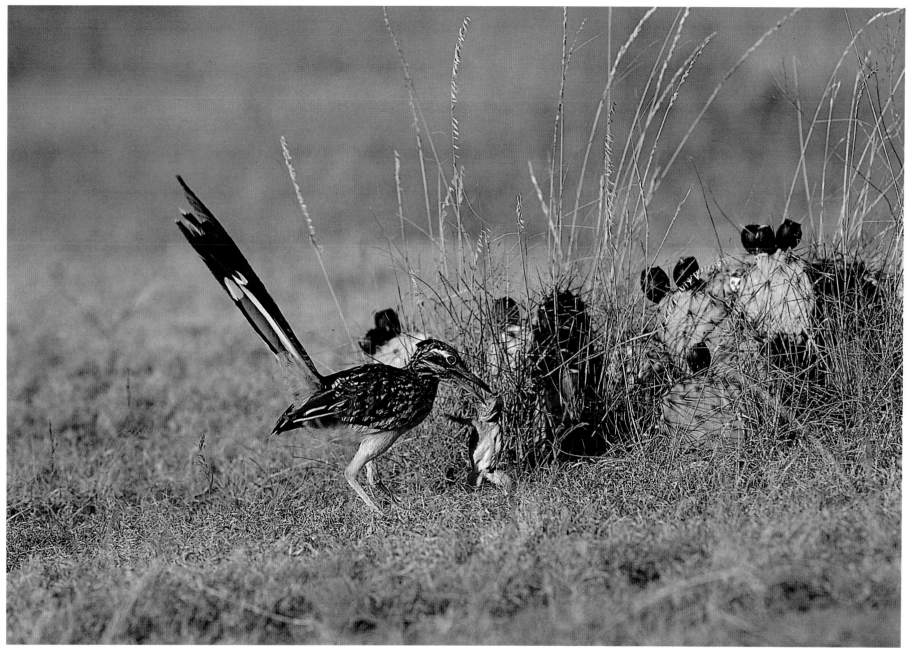

An adult pulls a collared lizard from a prickly pear patch.

Roadrunners do not have to nest near water, although they prefer a nesting site with a source of water nearby.

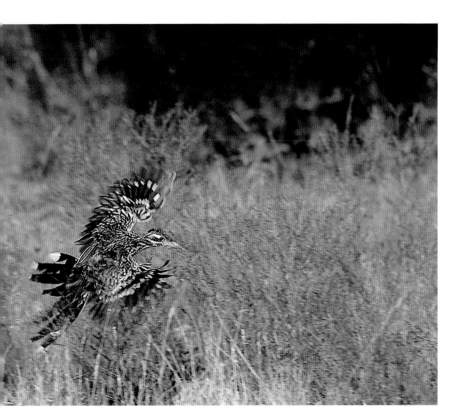

To scare up insects from the underbrush the bird jumps up and flaps its wings. The roadrunner catches the insects on the wing or watches where they land and picks them off.

Roadrunners are very fond of horned lizards—even the largest.

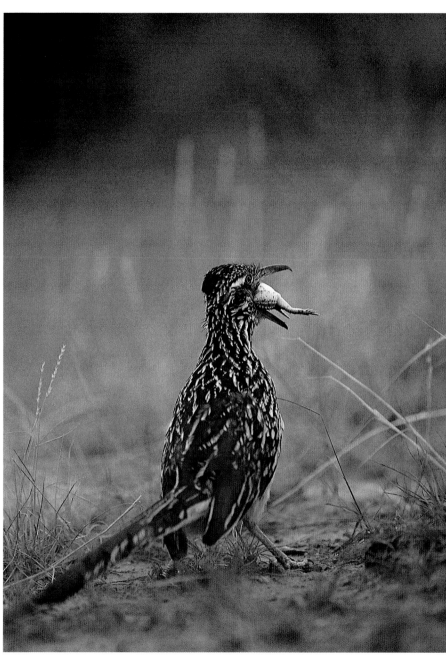

Roadrunner tracks in the badlands of northern Texas. Facing page–The badlands of northern Texas along the edge of the caprock.

Roadrunners are a common bird of the saguaro-studded desert of Arizona.

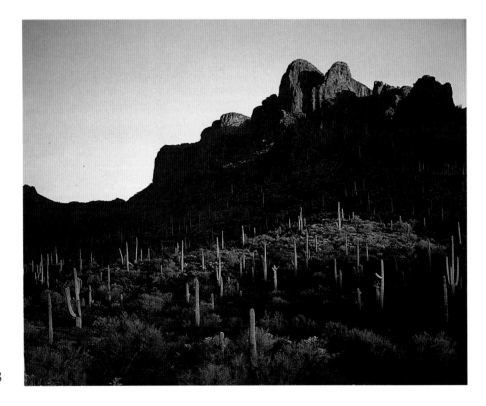

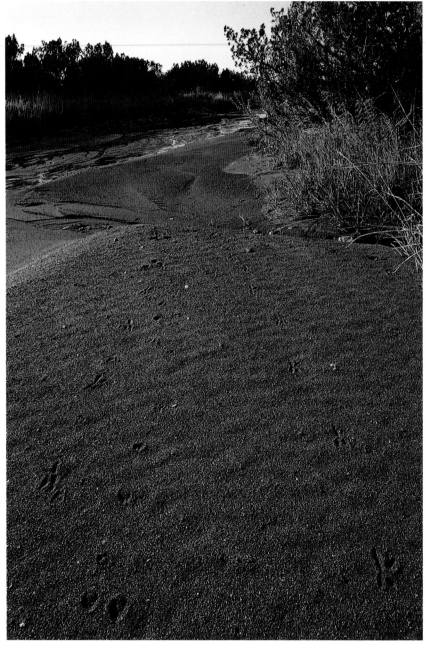

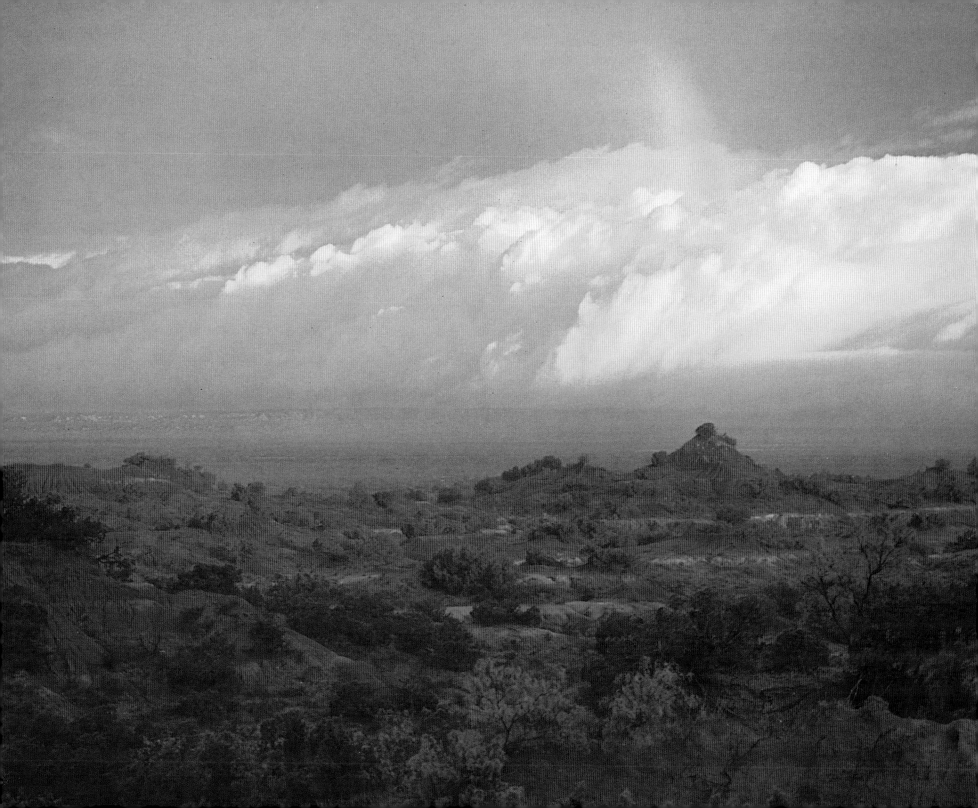

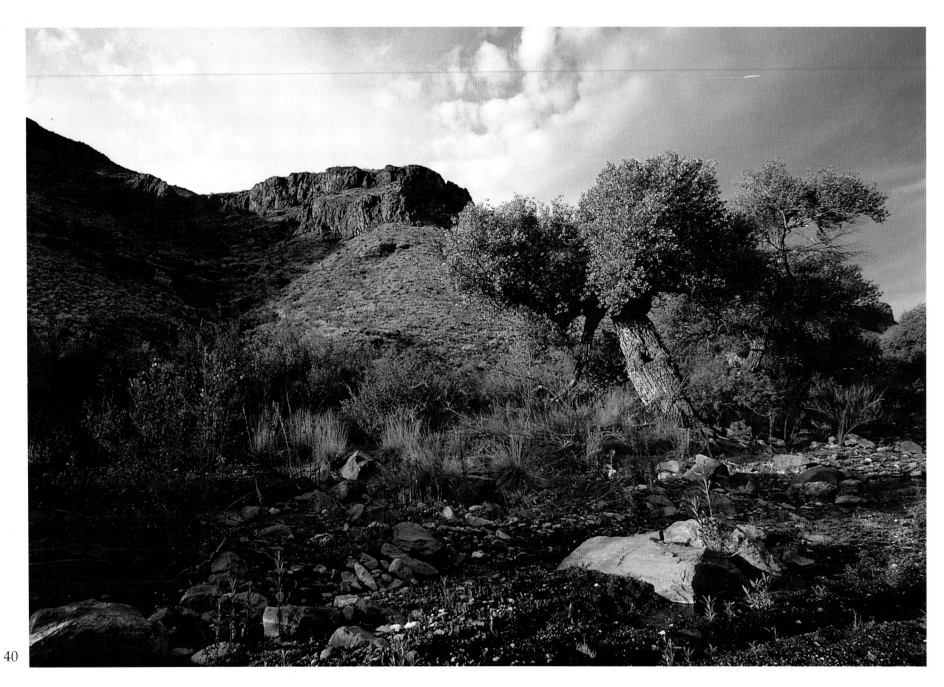

40

The canyons of the Big Bend region of West Texas.

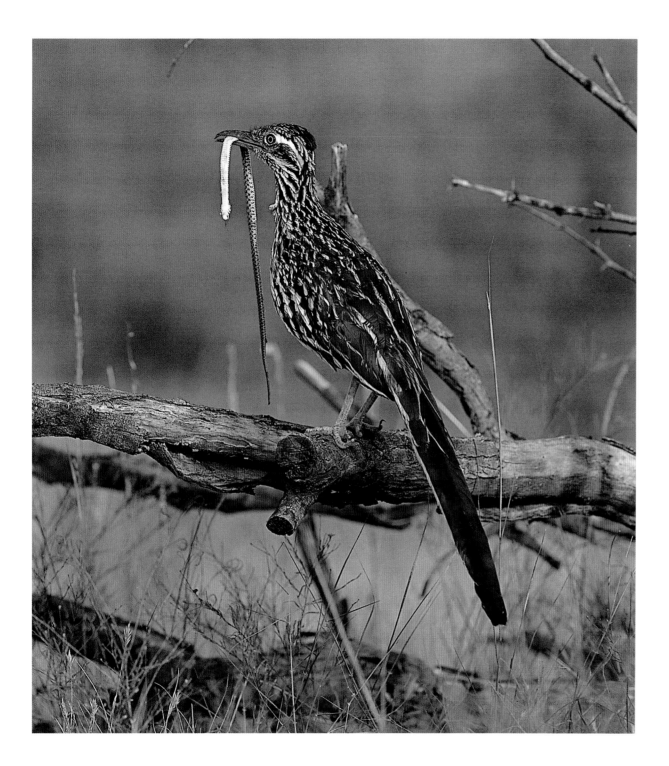

Garter snakes are a common food of road-runners.

41

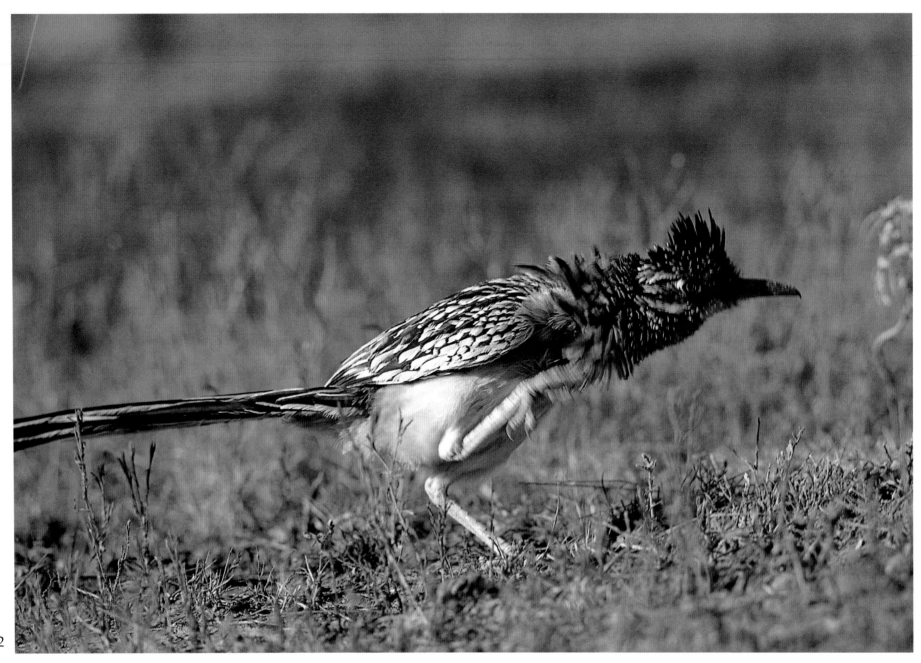

An adult pauses to scratch and preen.

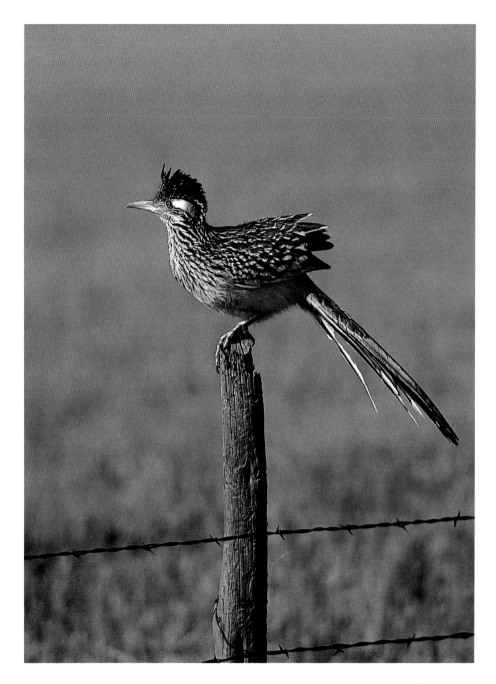

A common sight during the mating season. The male finds an elevated perch from which he can call.

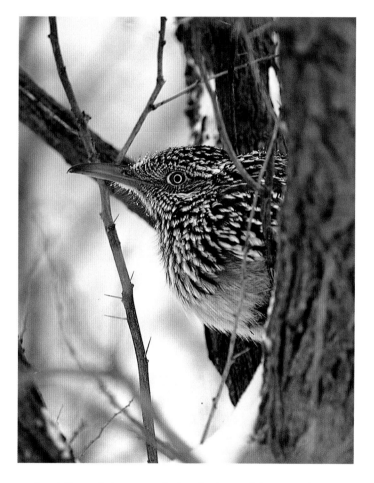

An adult roosts in a mesquite tree during a winter snow storm. Winter conditions are the most critical period for adult roadrunners. They have few natural predators, most deaths are due to winter stress.

43

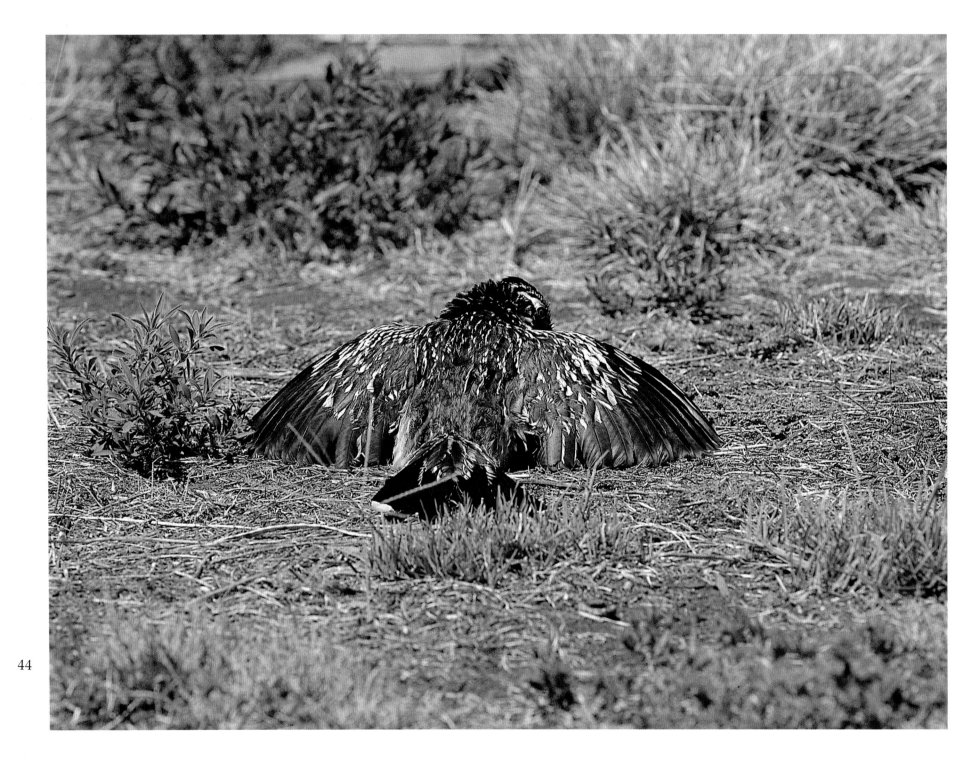

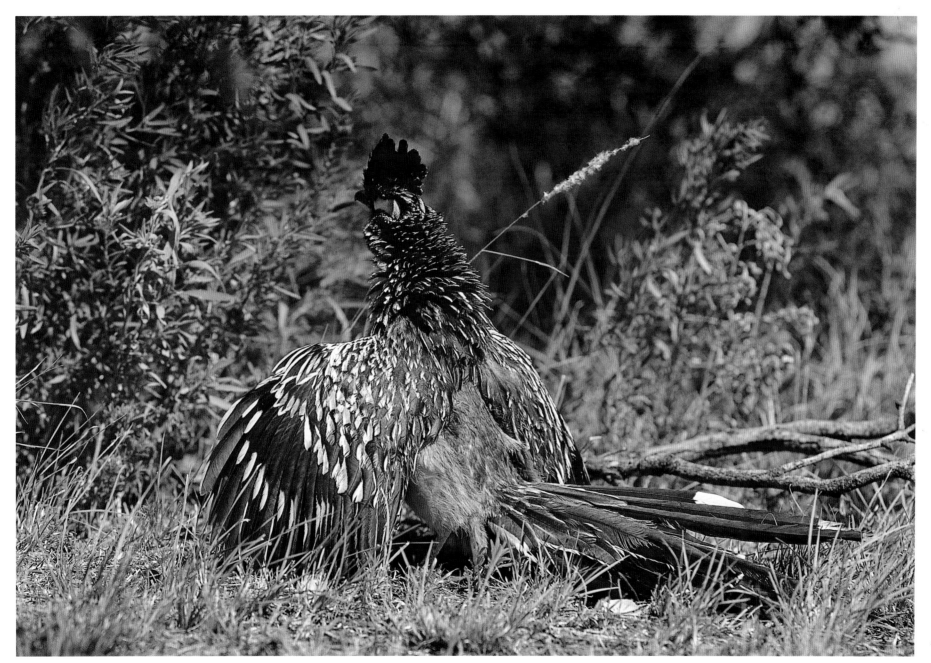

45

During extreme heat, adults spread their wings similar to the stance for warming up. The upper set of feathers are lifted to allow air flow between the layers without directly exposing the down feathers. In addition, the bird pulls its head under its body and crouches low to the ground. Often this action is accompanied by panting.

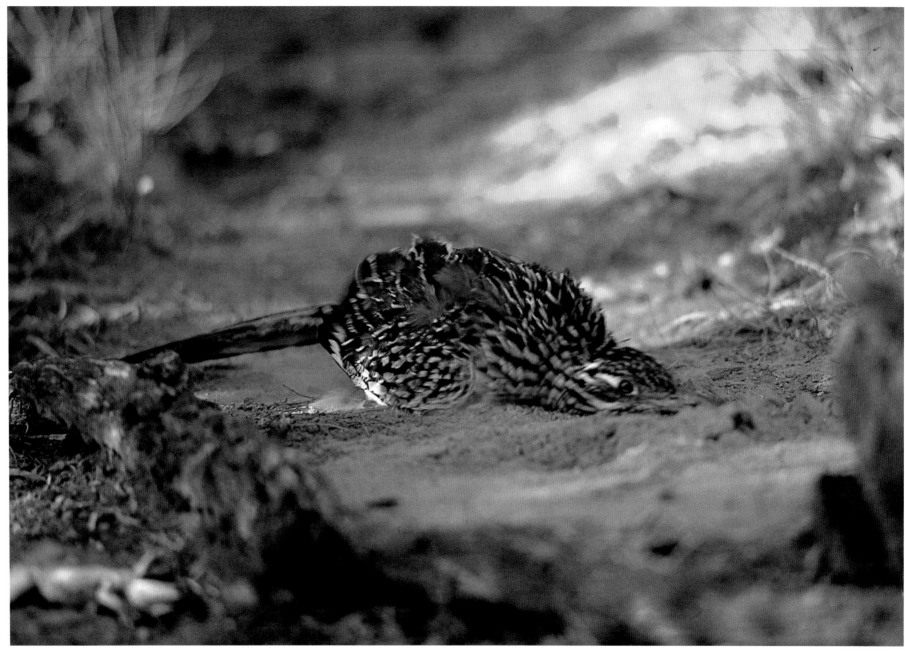

Dust bathing or "anting" is a common activity of adults whenever they come across a location where soft dirt is available.

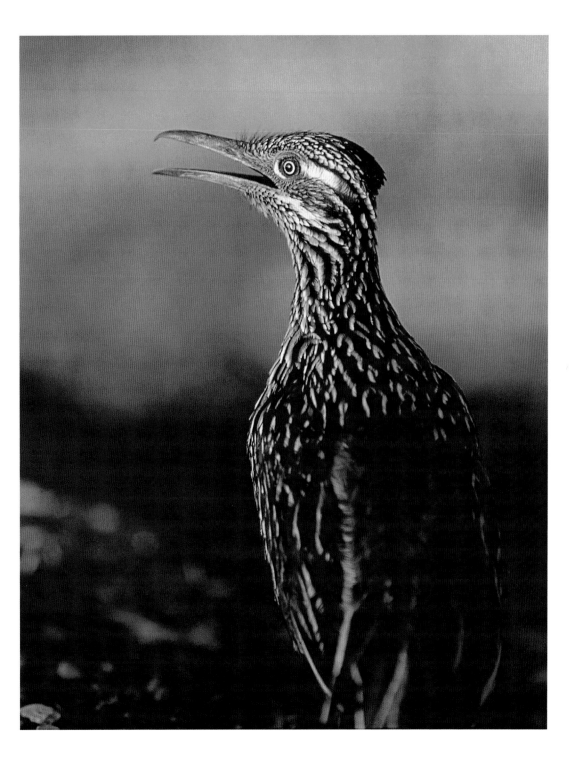

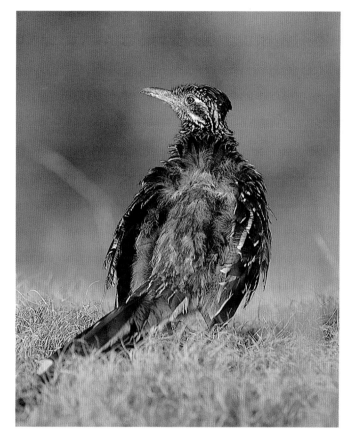

The energy-absorbing posture of the roadrunner in cool weather. The soft, black, downy feathers and dark skin on the back absorb heat. This allows the roadrunner to remain immobile during the cooler part of the day when prey species are still inactive.

47

A roadrunner pants in hot weather.

An adult walks down a cow path watching the edges of the trail for prey items. In thick grass the roadrunner keeps its head down and brushes the grass forcing the insects to jump. When they do the roadrunner grabs them.

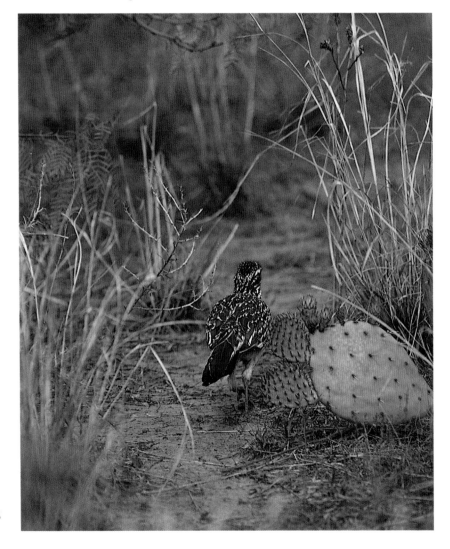

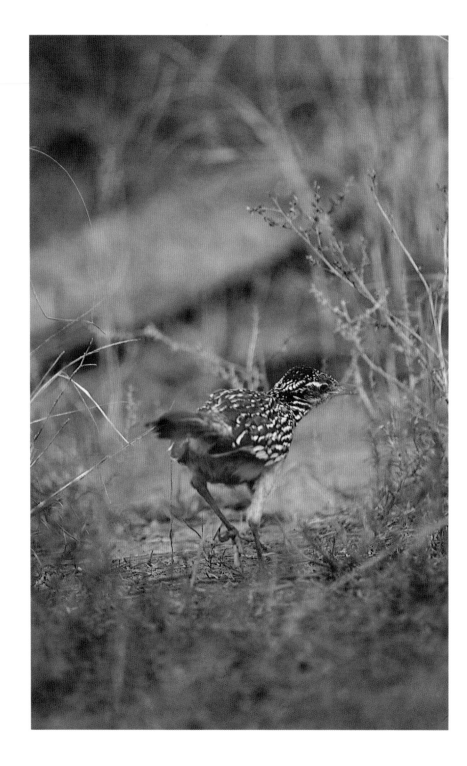

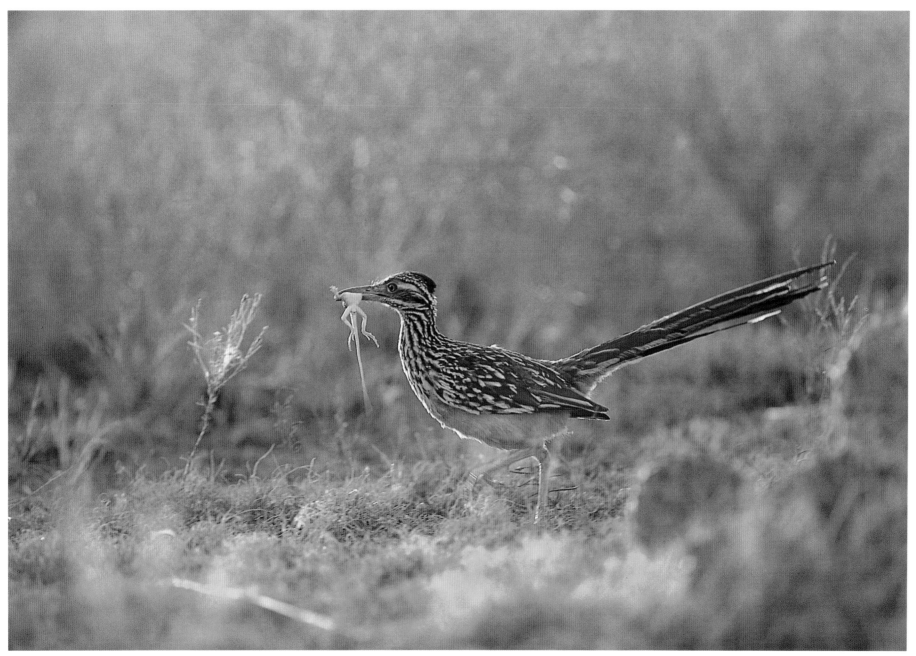

An adult with a juvenile collared lizard.

49

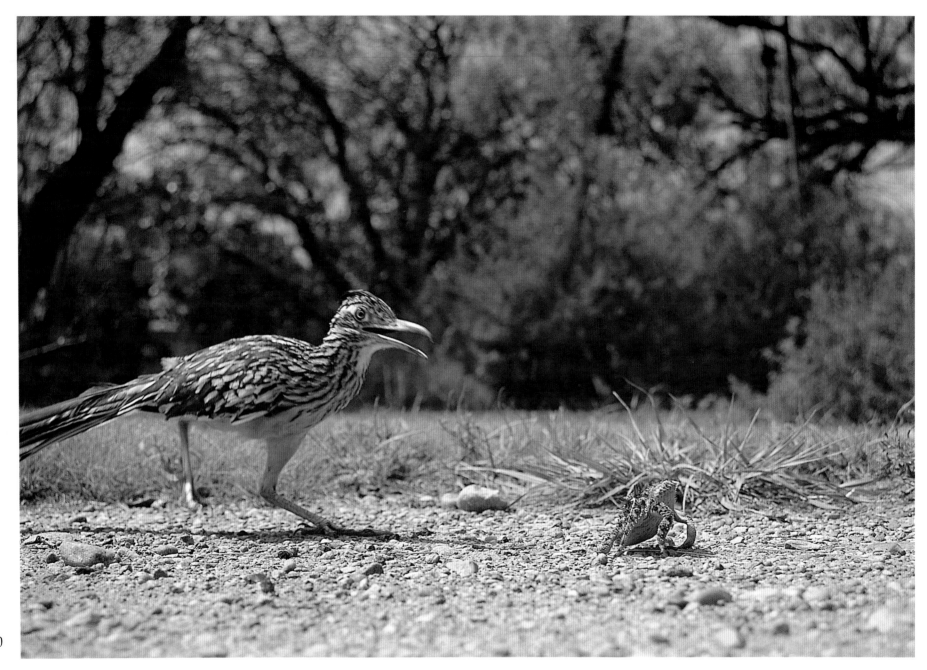

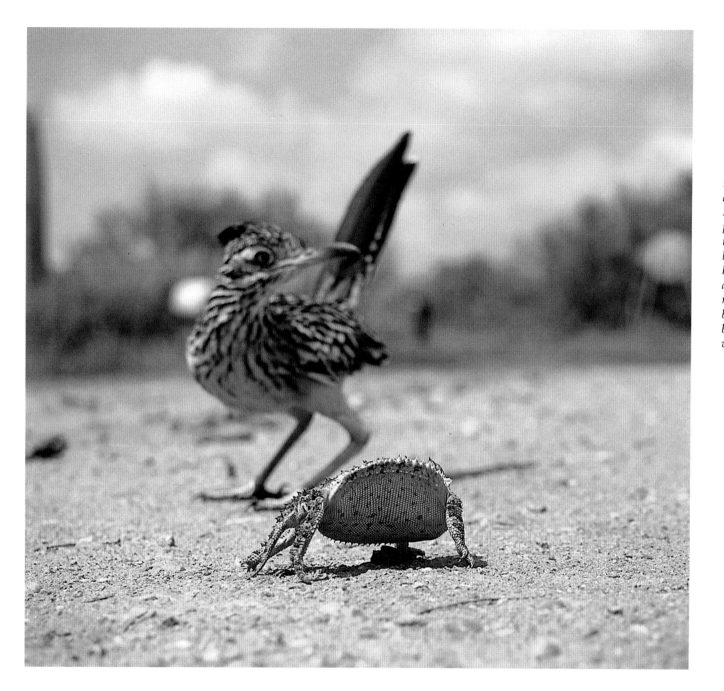

If a horned lizard sees a roadrunner approaching, it assumes a defensive position. It faces the bird head on, exposing as much surface area to the attacker as possible. As the bird circles the prey the horned lizard pivots to keep facing the attacker. If the horned lizard maintains this position, the bird will break off the attack, but if it turns to flee, the bird will attack.

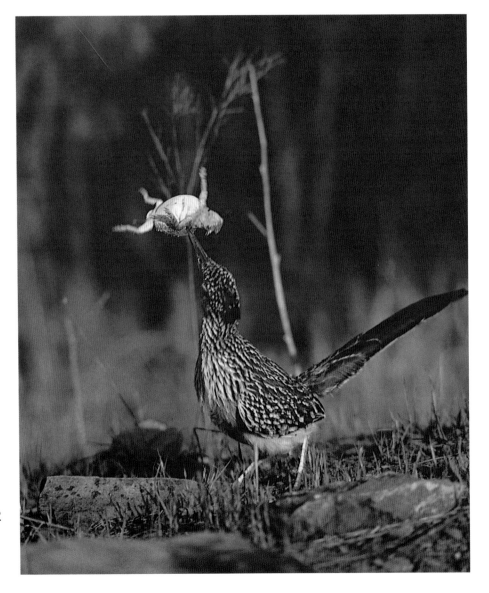

Once a horned lizard is captured, the roadrunner locates something—a rock, stick, or even a cow chip—that it can beat the prey against to crush the bones so the bird can swallow it whole. It takes the bird about fifteen minutes to crush a horned lizard.

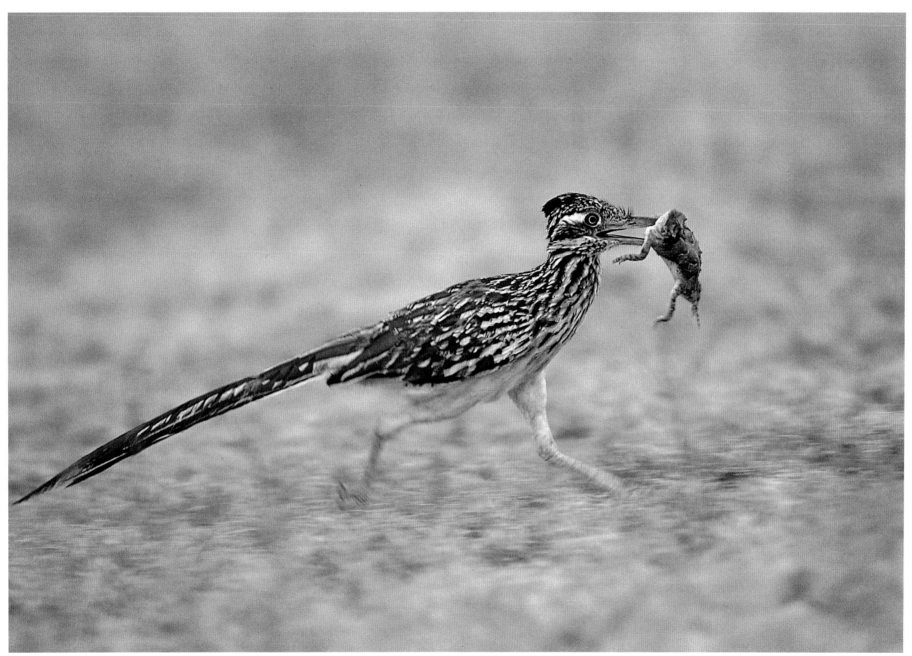

53

A roadrunner heads back to the nest with its captured prey. They try to beat their prey in an area of dense shrubs, perhaps as protection from scouting birds of prey.

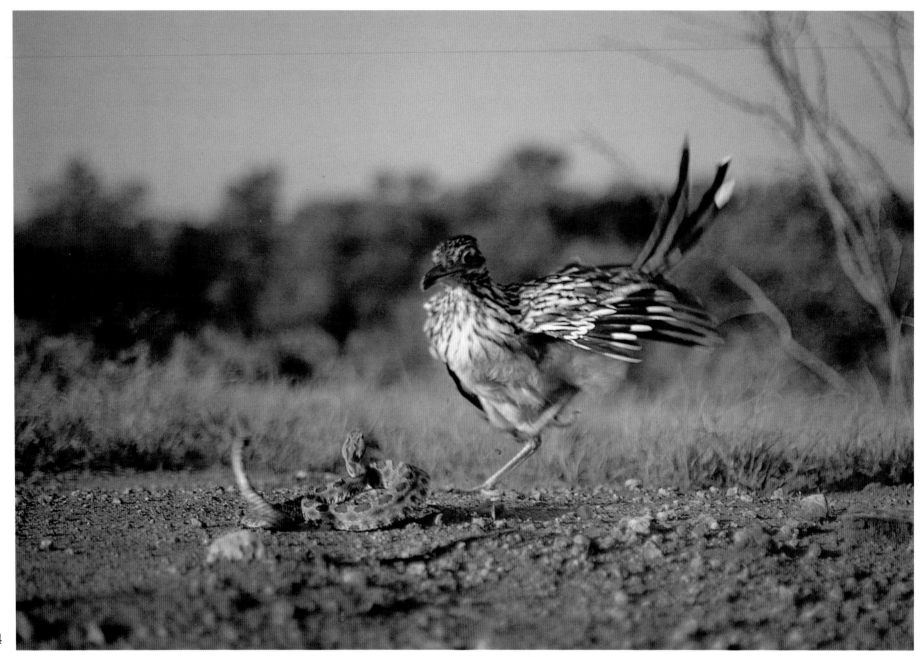

A roadrunner attempts to surprise a diamondback rattlesnake. In this sequence, the bird feints an attack by leaping above the snake to throw it off guard. The roadrunner tries to grab the snake's head in its beak.

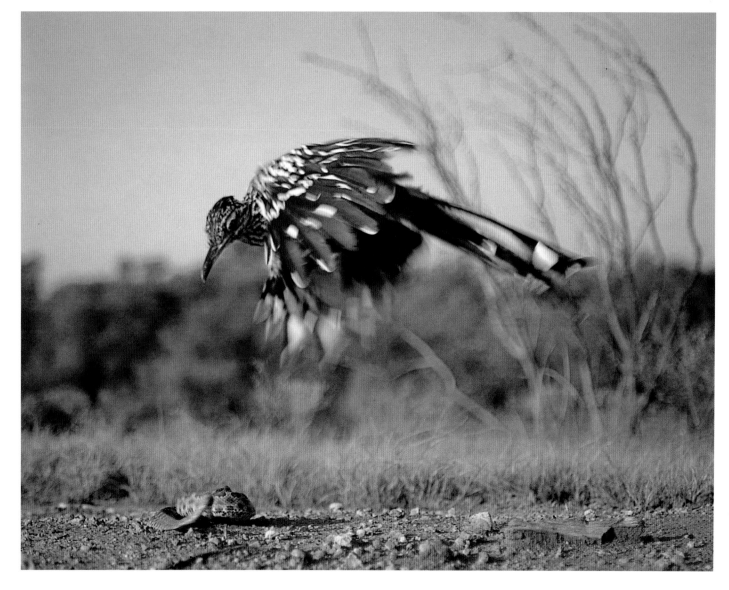

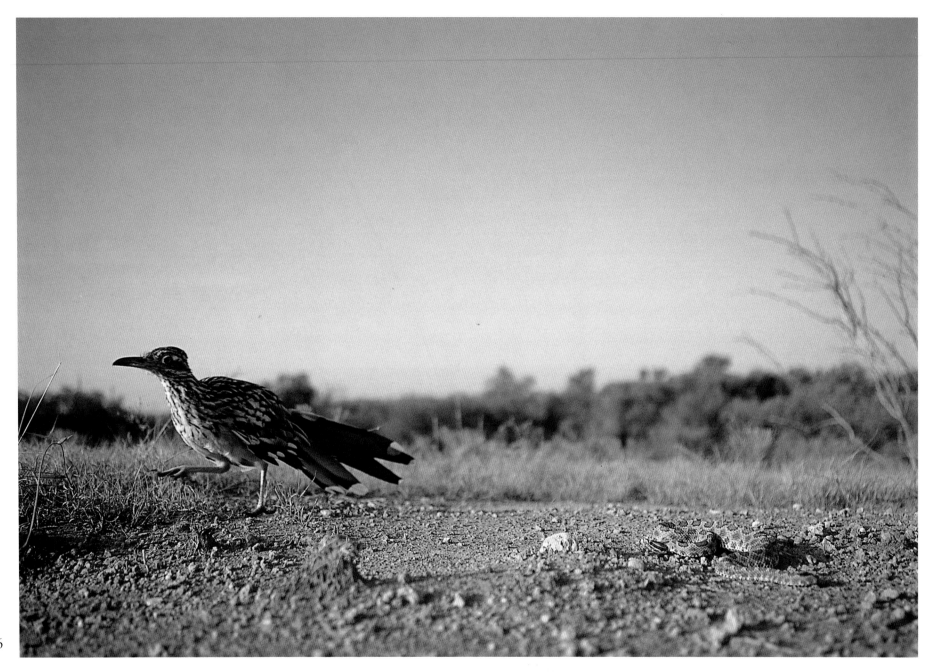

The bird was unsuccessful in its attempt on this snake and walks away.

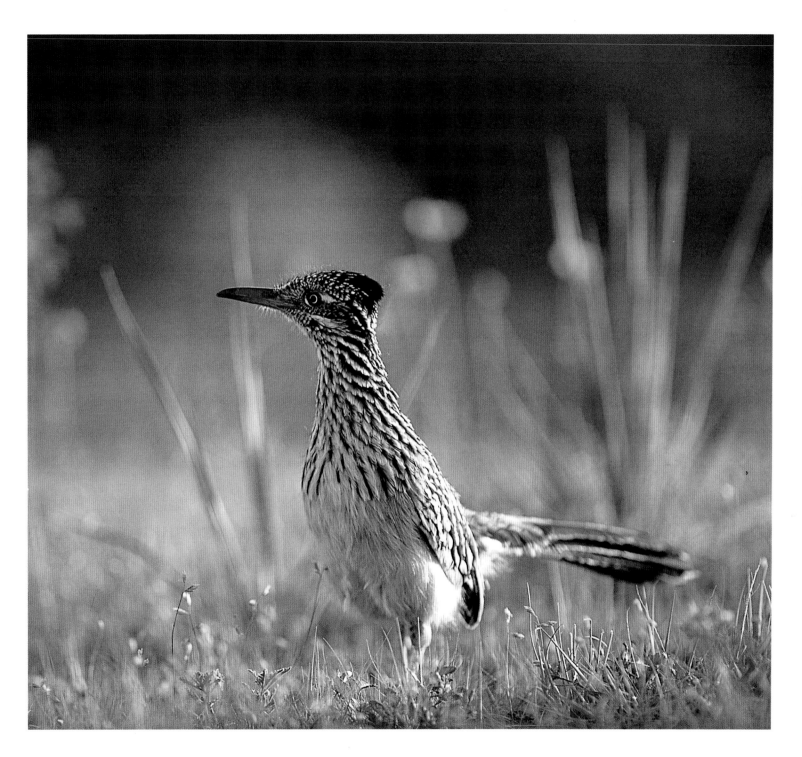

In the late afternoon, a roadrunner takes a break from hunting.

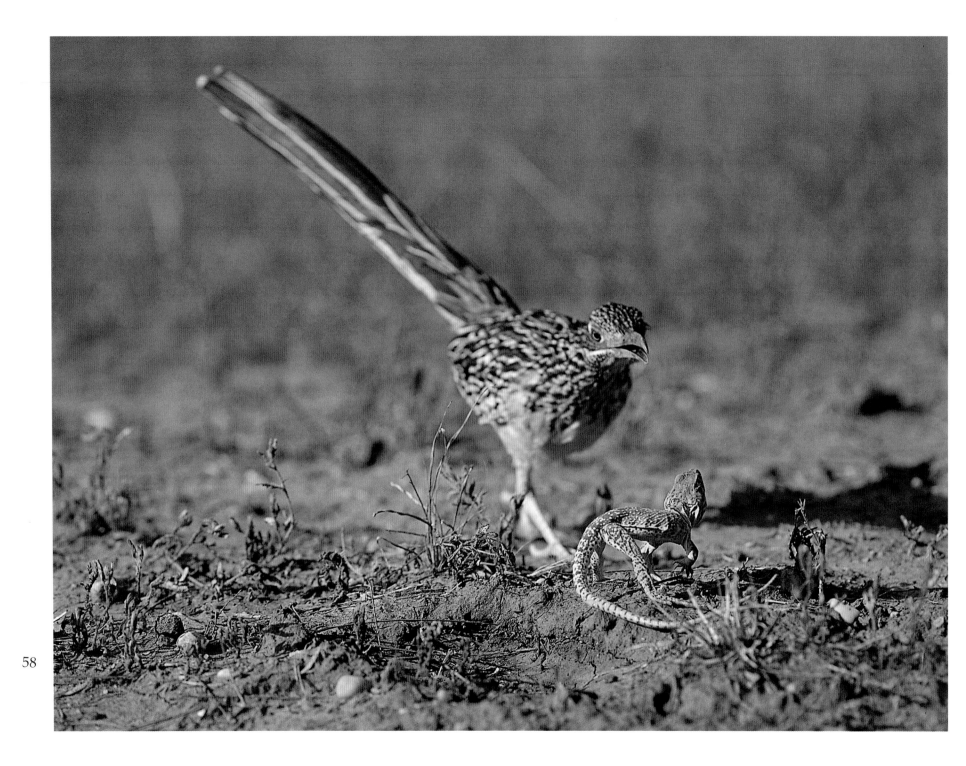

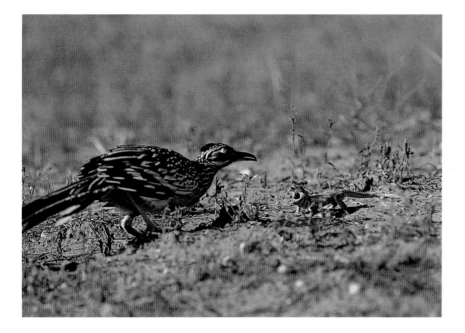

A collared lizard repelling an attack. The lizard opens its mouth and elevates its body. In this attack, the lizard is very aggressive and leaps at the roadrunner. The roadrunner leaps backwards. The lizard continues to attack and actually grasps the beak of the roadrunner. The roadrunner breaks off the attack.

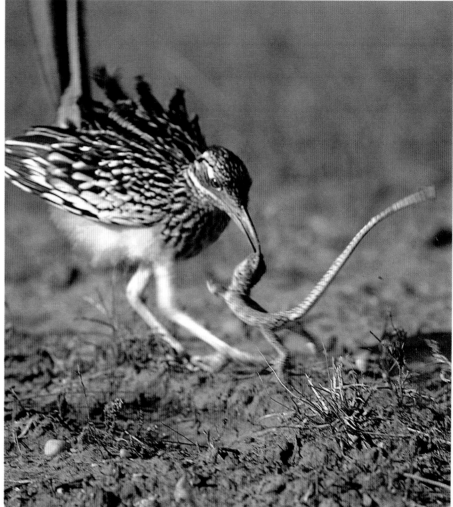

When other prey items are scarce, roadrunners will occasionaly eat berries. This adult is hunting for tasajillo berries.

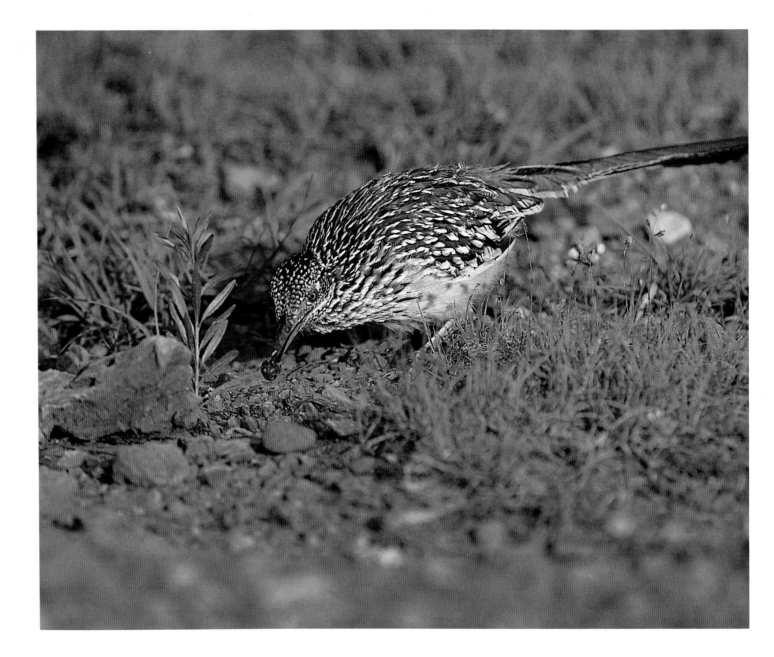

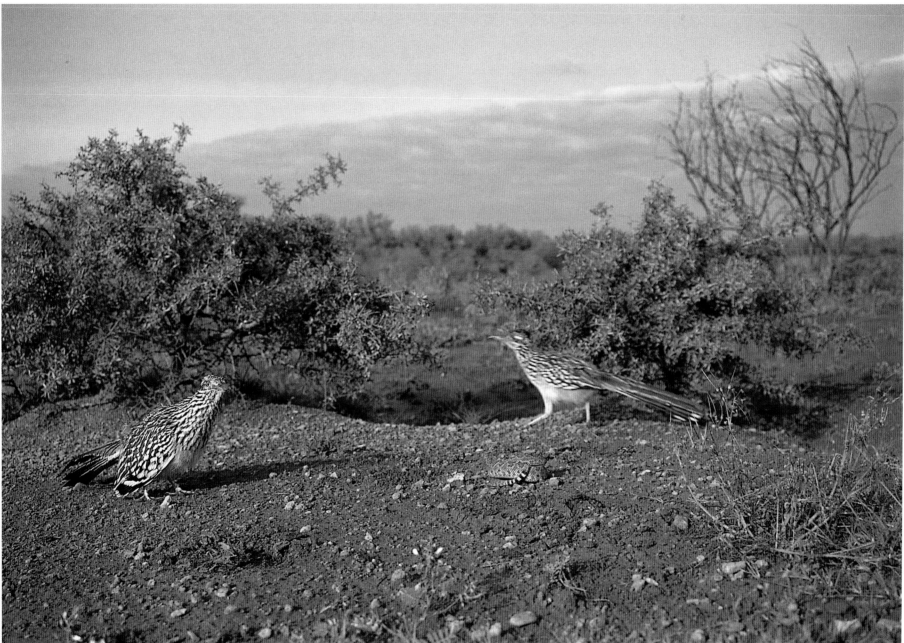

61

A pair of birds circles a snake looking for an opening to attack.

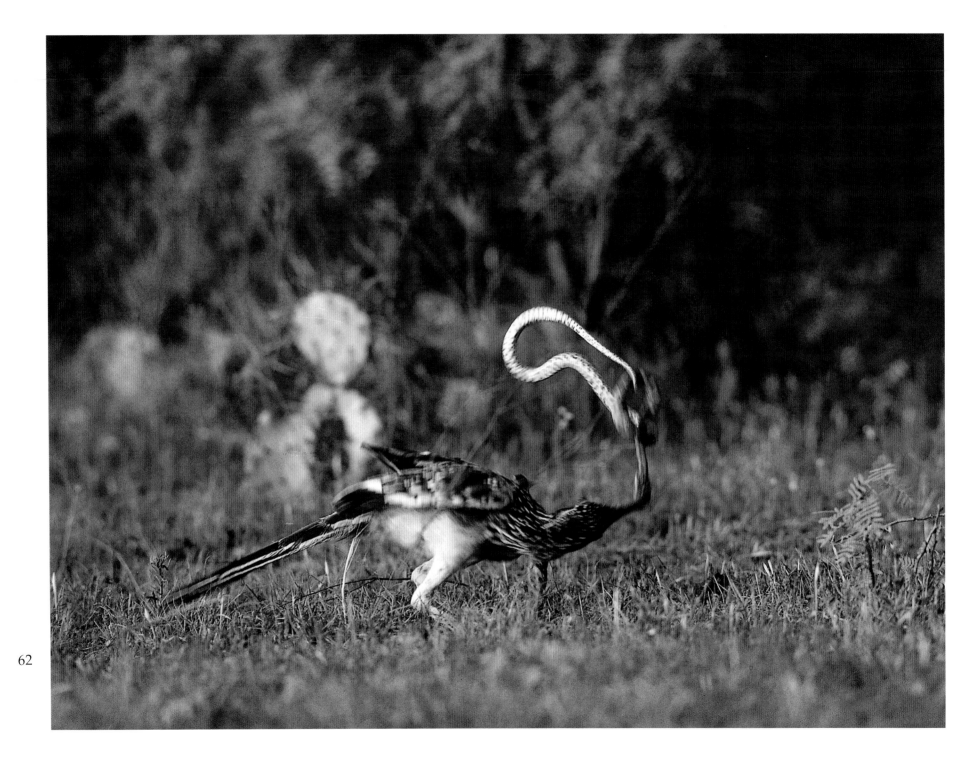

Adults use the same technique to kill nonpoisonous snakes that they use for lizards: strike the head first, beat the body until crushed, then peck the head until bloody, indicating that the skull has been crushed enough so the bird can swallow the prey whole.

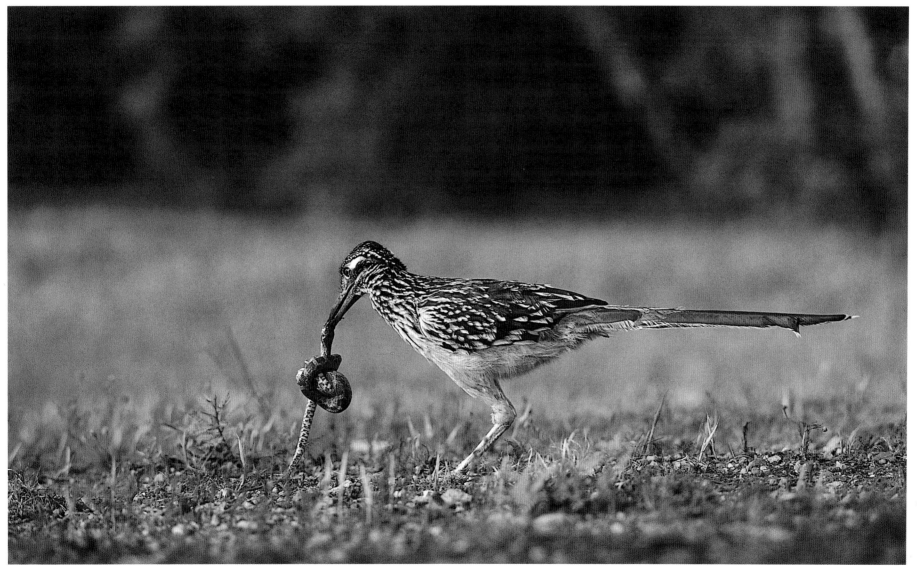

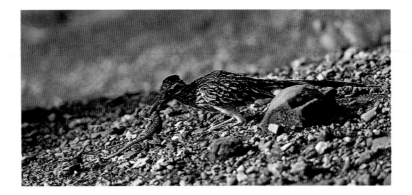

Most large lizards can successfully defend themselves from a roadrunner attack. In this sequence the roadrunner got the lizard. Once the lizard had been beaten the bird stopped and watched the lizard for a while and then resumed beating it for several more minutes.

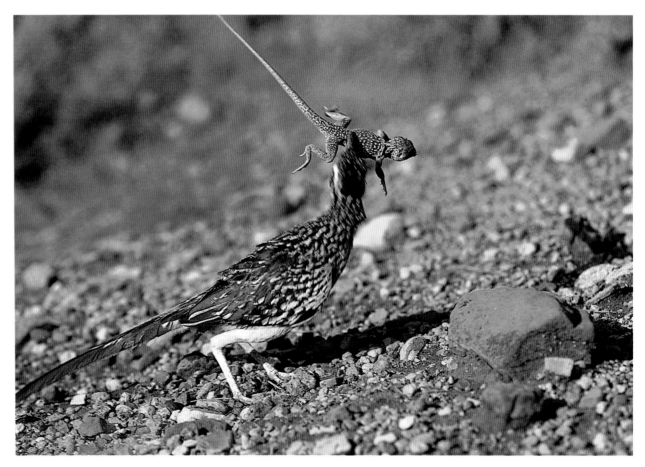

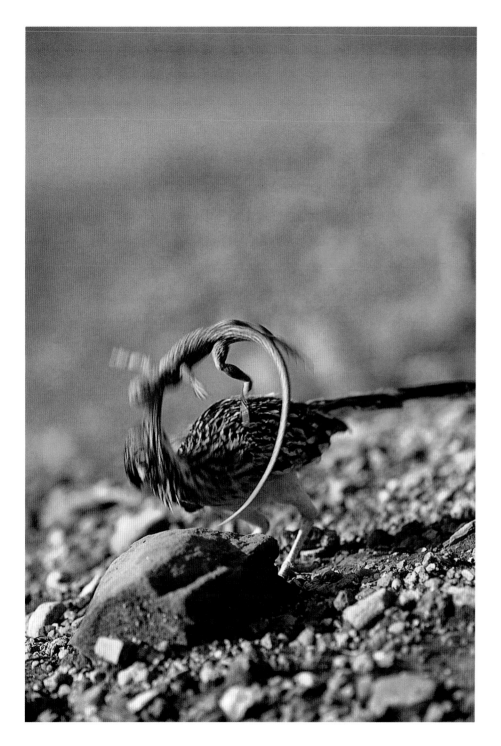

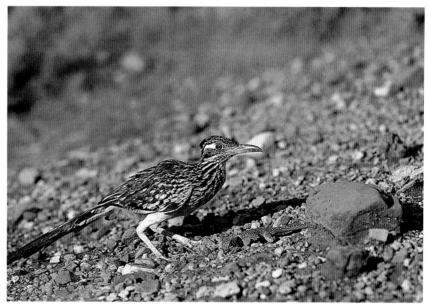

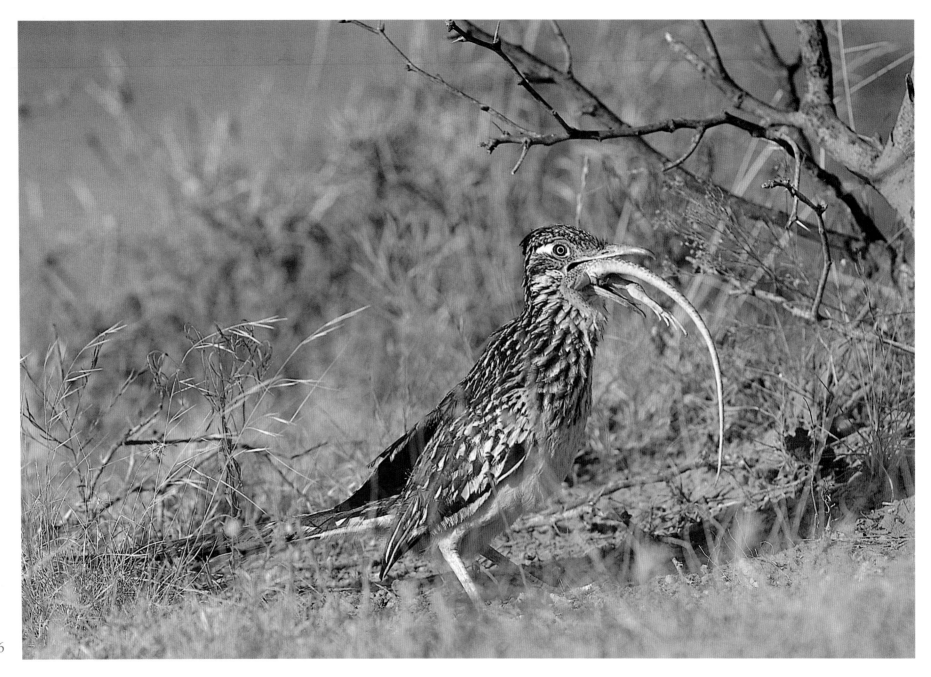

An adult swallows a collared lizard.

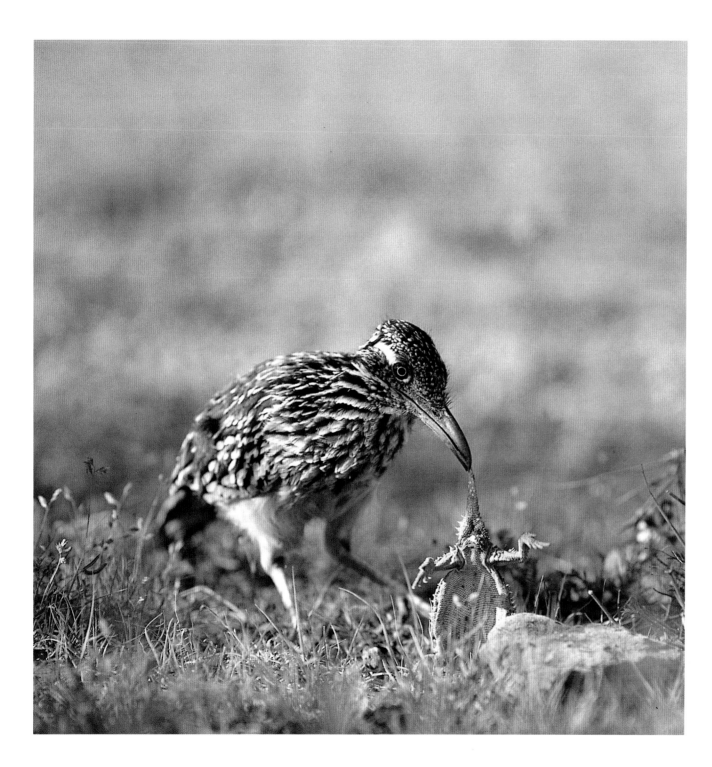

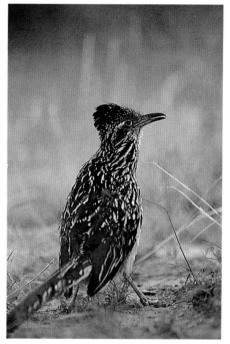

Once the prey has been crushed—in this case a horned lizard—the bird will swallow it whole.

67

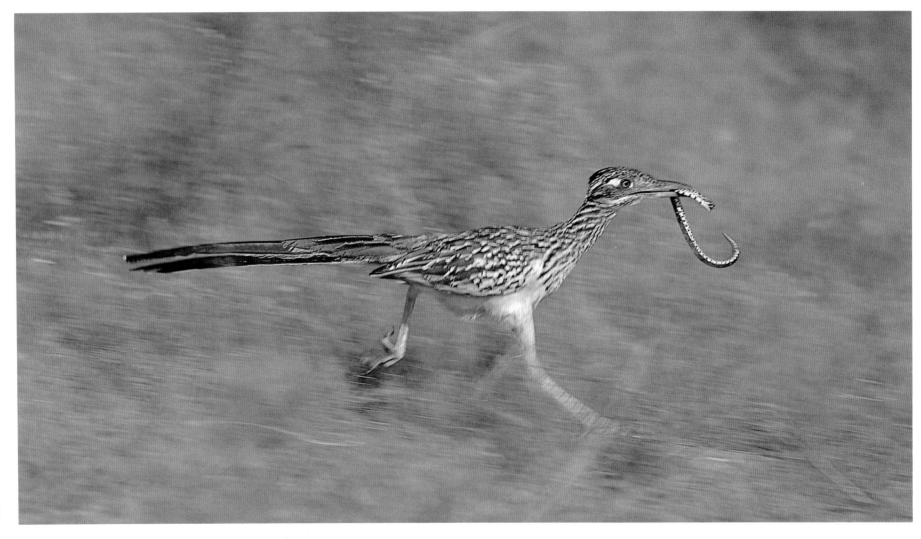

An adult races off with a hog-nosed snake.

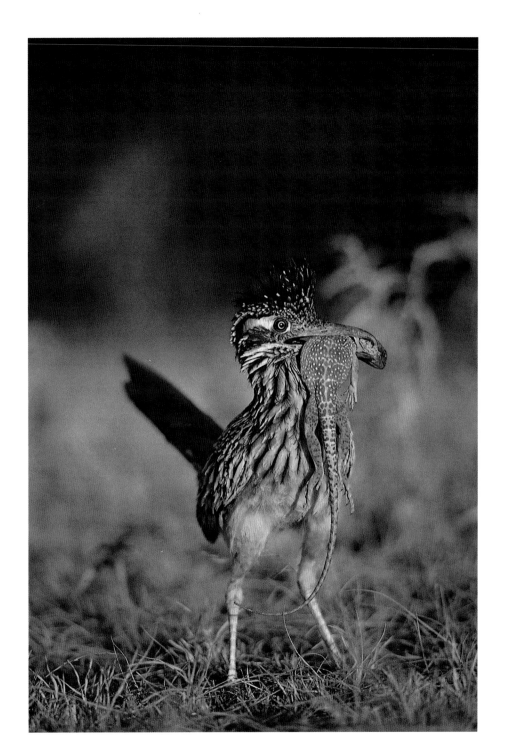

Adult male holding male collared lizard.

Insects such as this praying mantis make up a large portion of the roadrunners' diet.

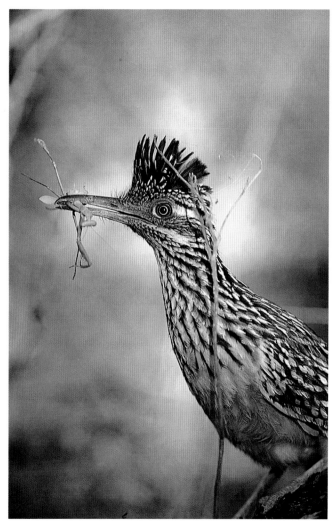

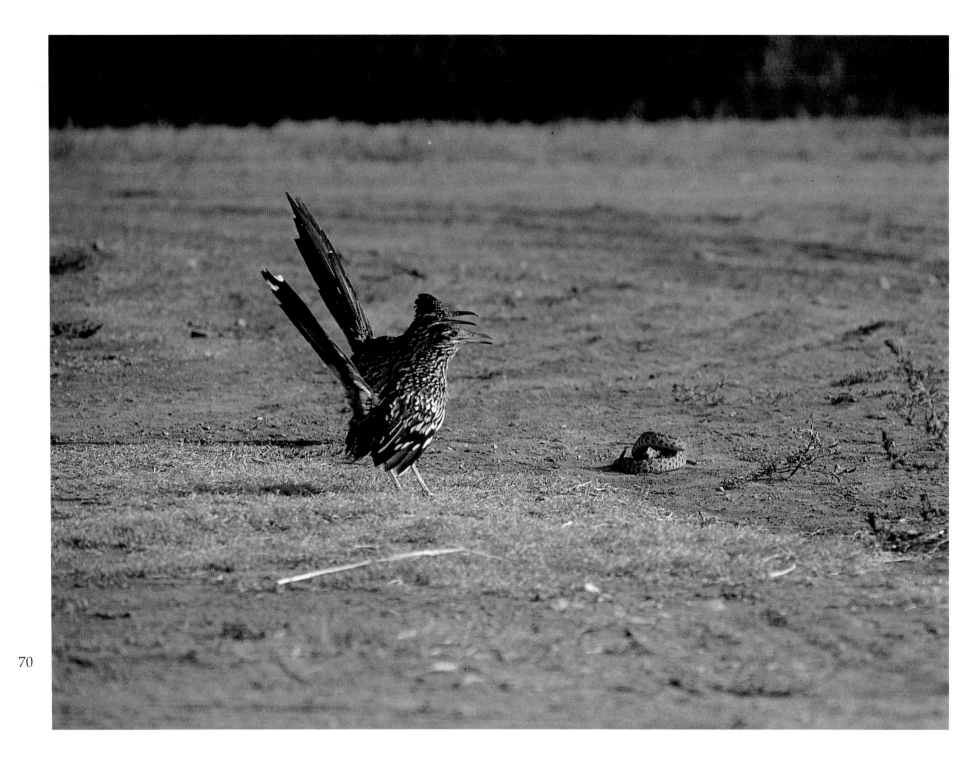

Sometimes the adults team up to attack a snake. The birds begin by circling the snake.

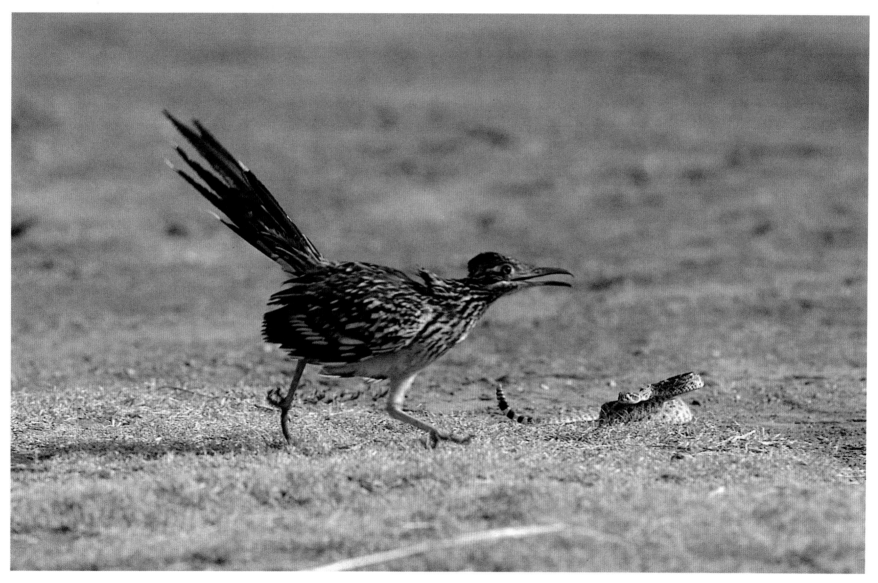

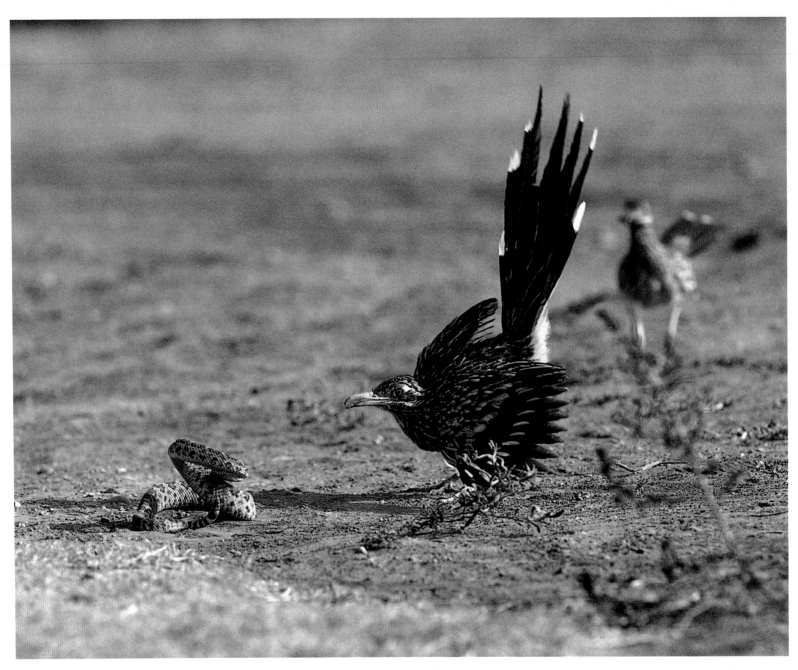

The attack is made by the first bird to find an opening. Once the snake is captured and killed it is brought back to the nest if there are young.

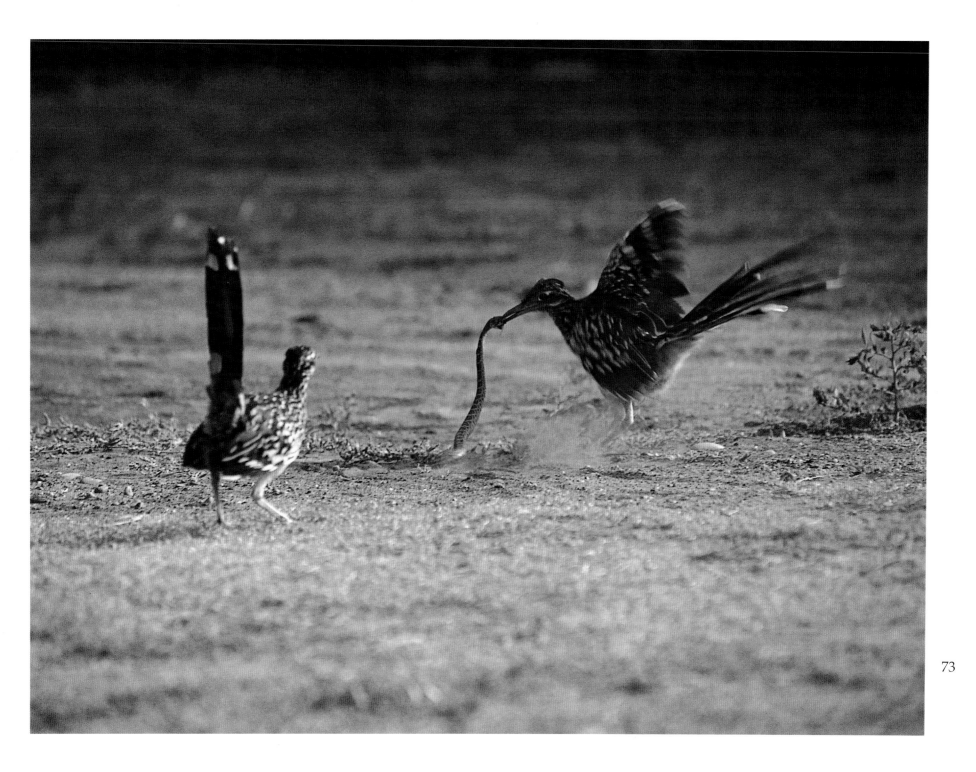

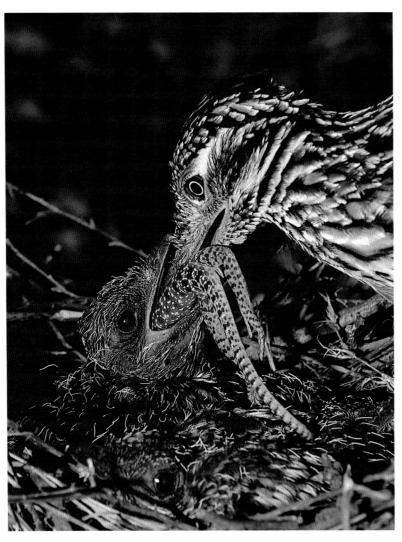

An adult feeds a collared lizard to a ten-day-old juvenile.

A roadrunner will often loop a long snake—here a bull snake—around its beak before carrying it away.

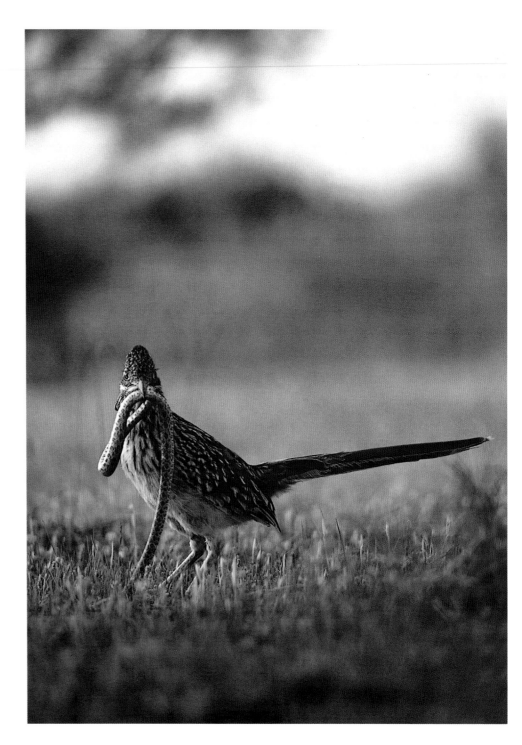

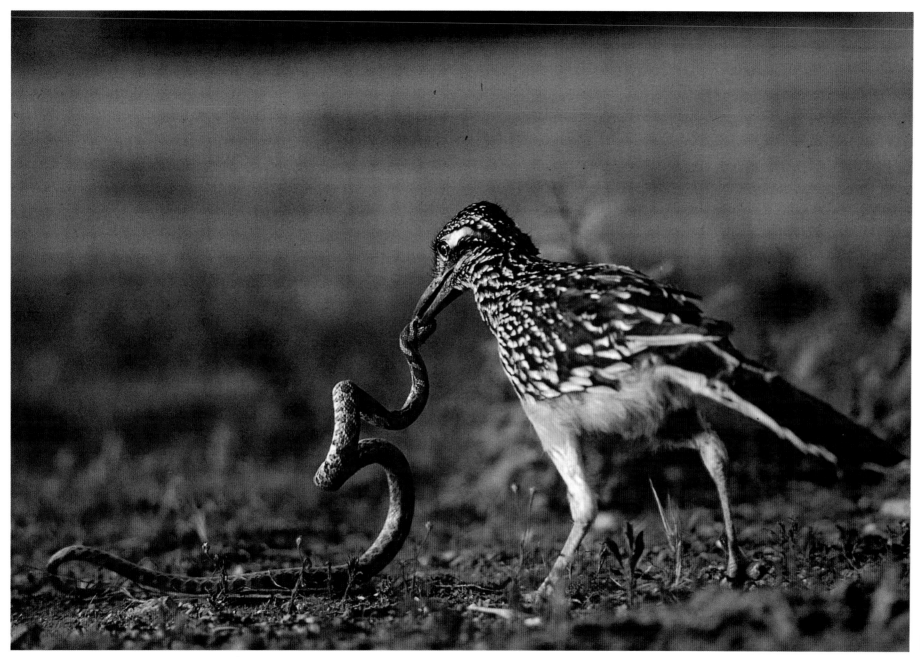

Typical head hold—the bird grabs the upper mandible of the snake.

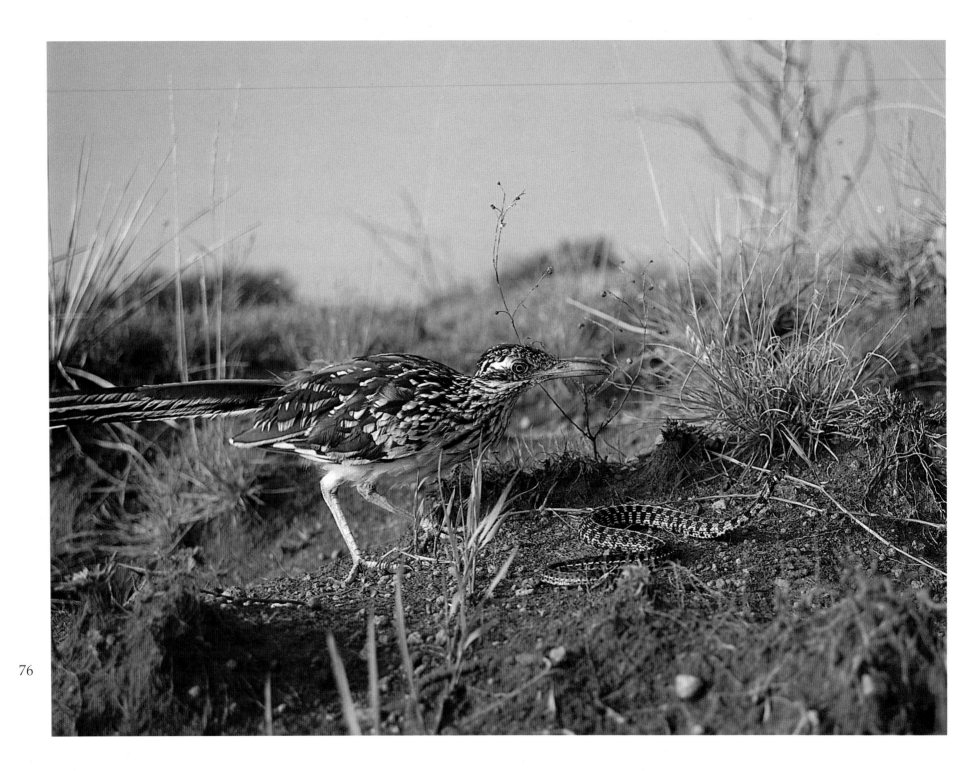

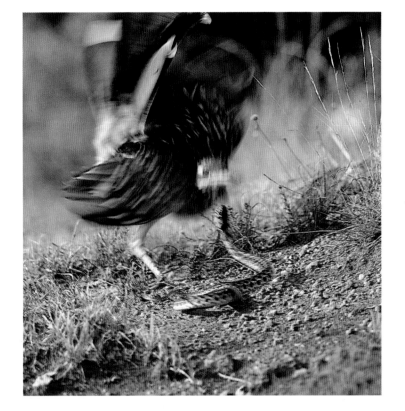

This nonpoisonous snake is too large for this roadrunner. The bird makes the classic grab at the head but releases it. The snake rears up and crawls away with the roadrunner following along behind.

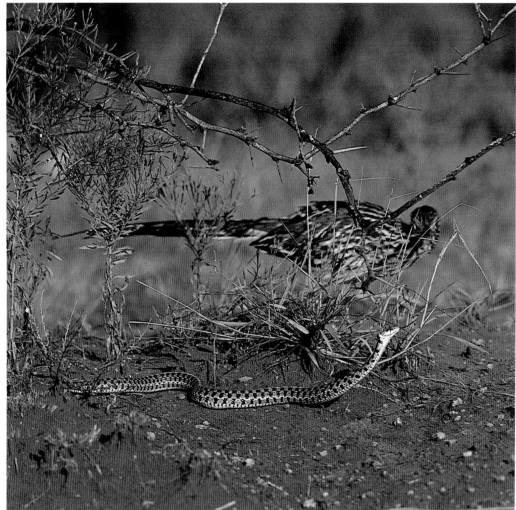

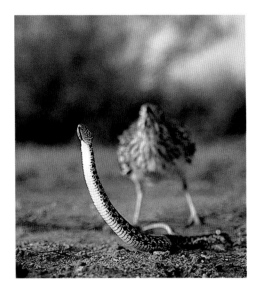

Occasionally the roadrunner grabs the tail of the snake but does not make any further attempt to attack, and eventually stops pestering the snake.

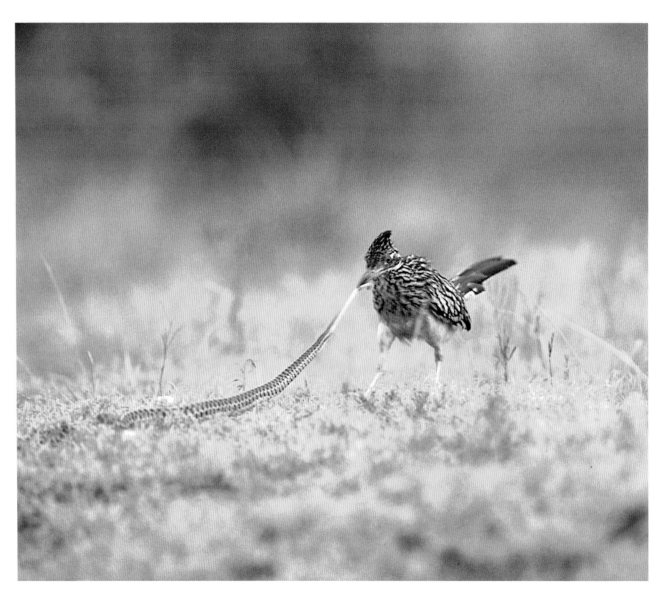

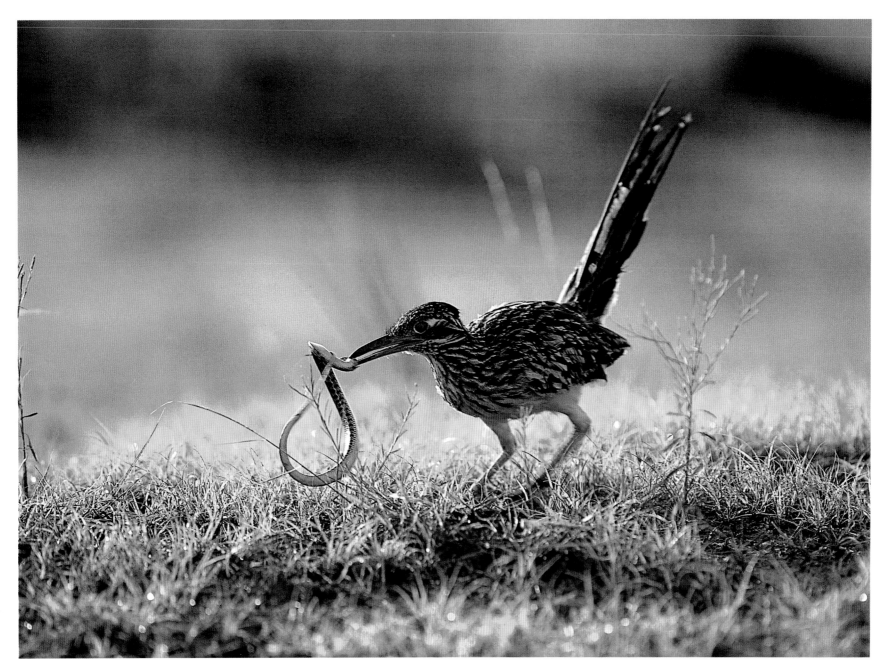

A roadrunner killing a hog-nosed snake.

After mating the male forcefully reclaims the "gift" presented to the female during the courtship ritual.

A male roadrunner calls to a female. The mating call, which is given by either sex, is a mellow cooing that often is heard in the early morning or late afternoon throughout the spring and summer.

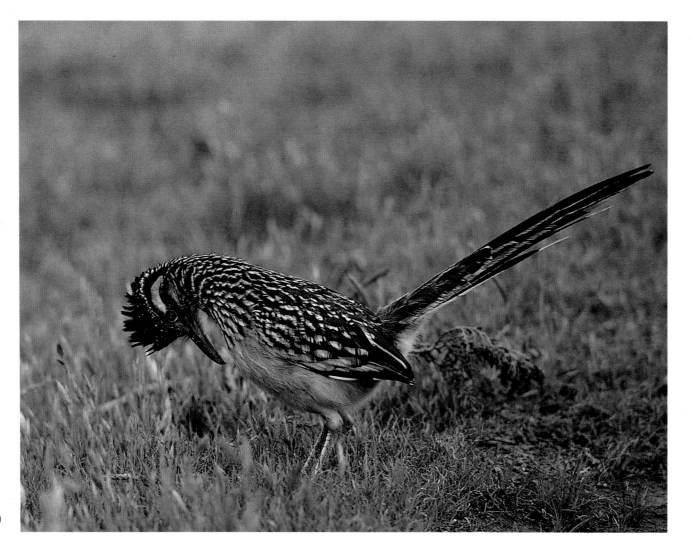

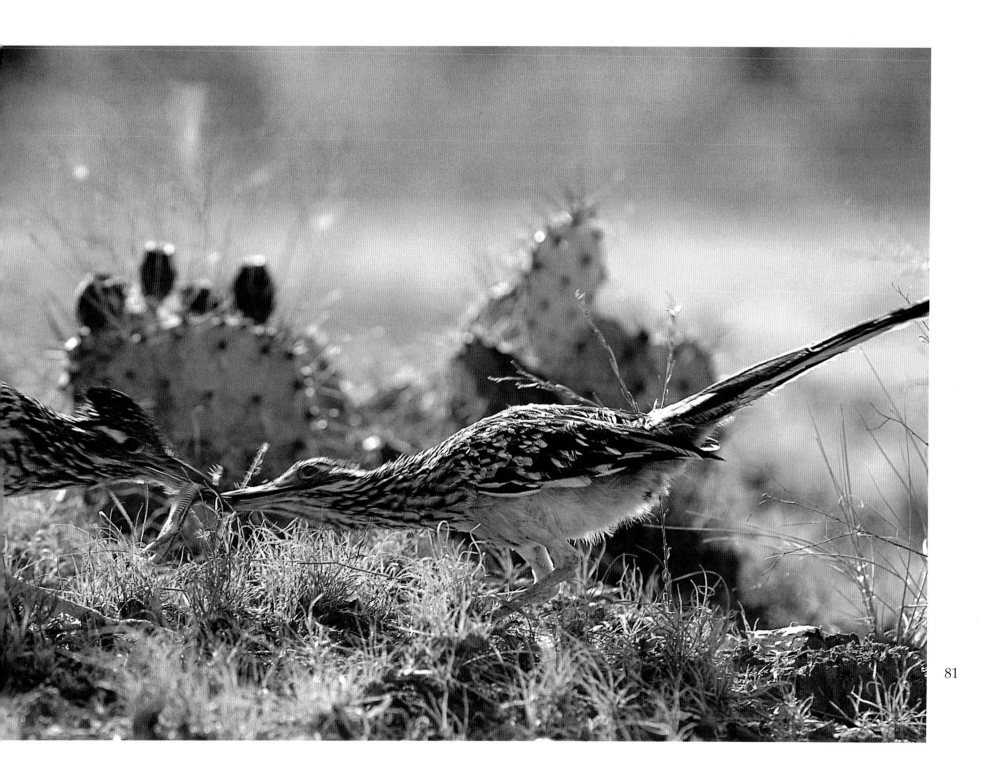

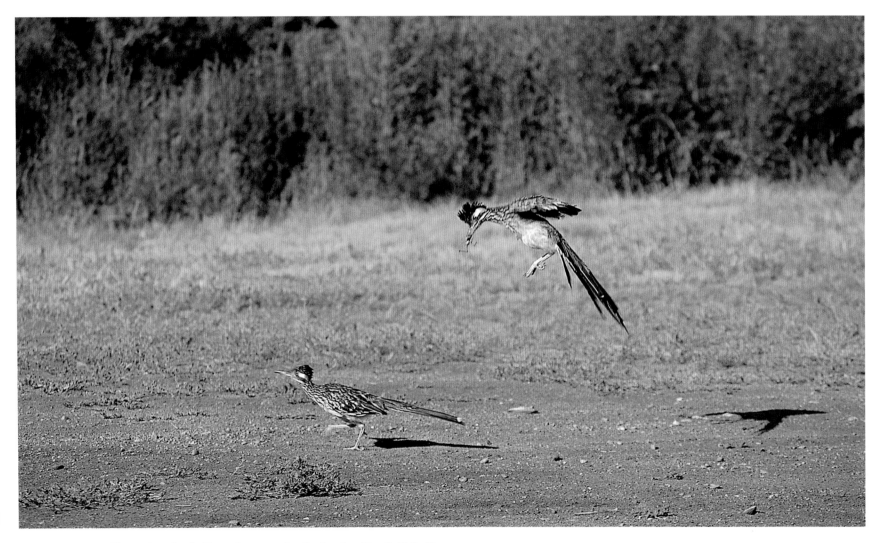

The mating ritual. The male approaches the female with a "gift." He springs into the air and hovers above the female. If she is not interested she moves away.

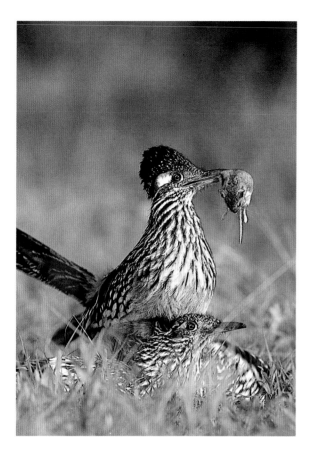

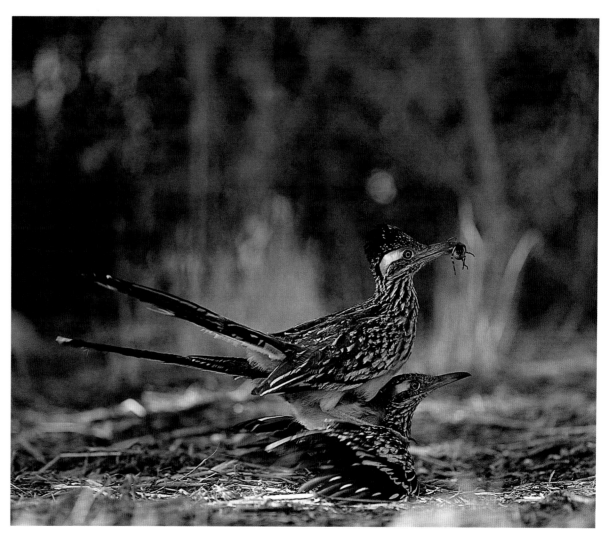

If the female is receptive, she stops and the male mounts her back.

83

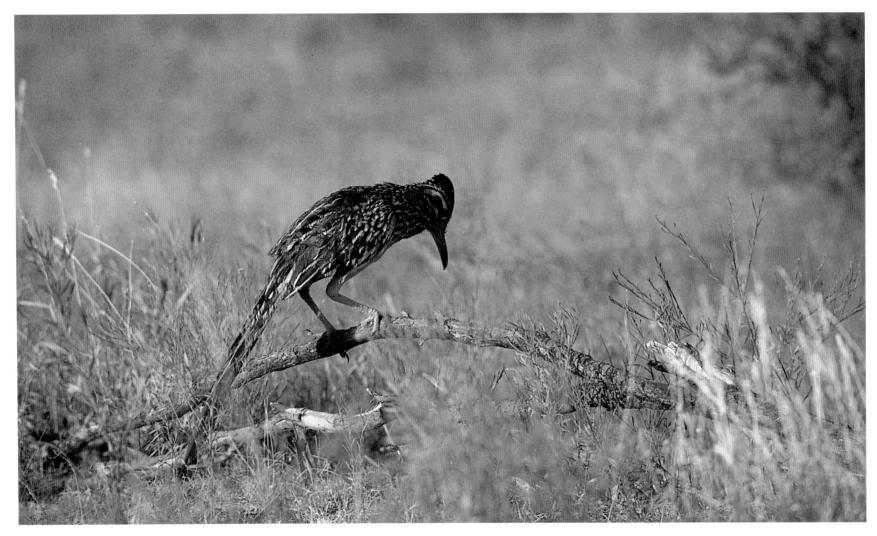

A male will try to find an elevated spot to call for females.

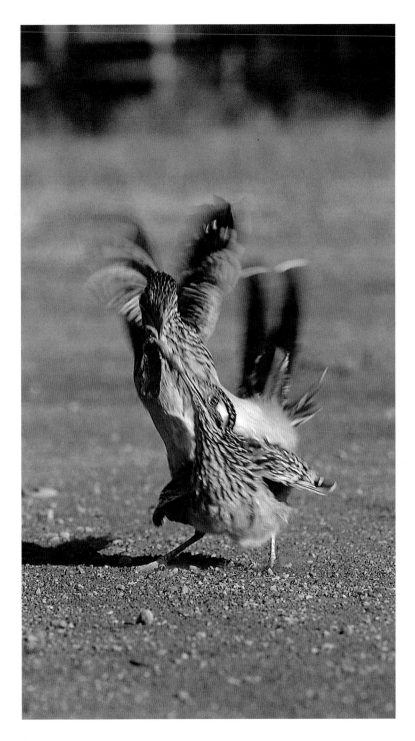

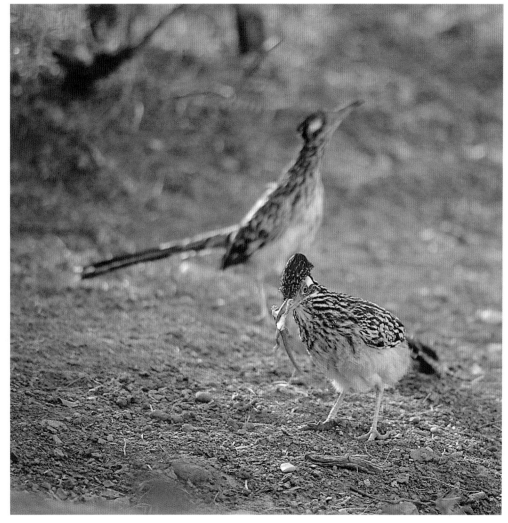

85

During copulation the female attempts to grab the gift. After copulation the birds circle each other. While circling, the female points her head straight up and bobs her head, the male keeps his head low. Note that the male has reclaimed the gift.

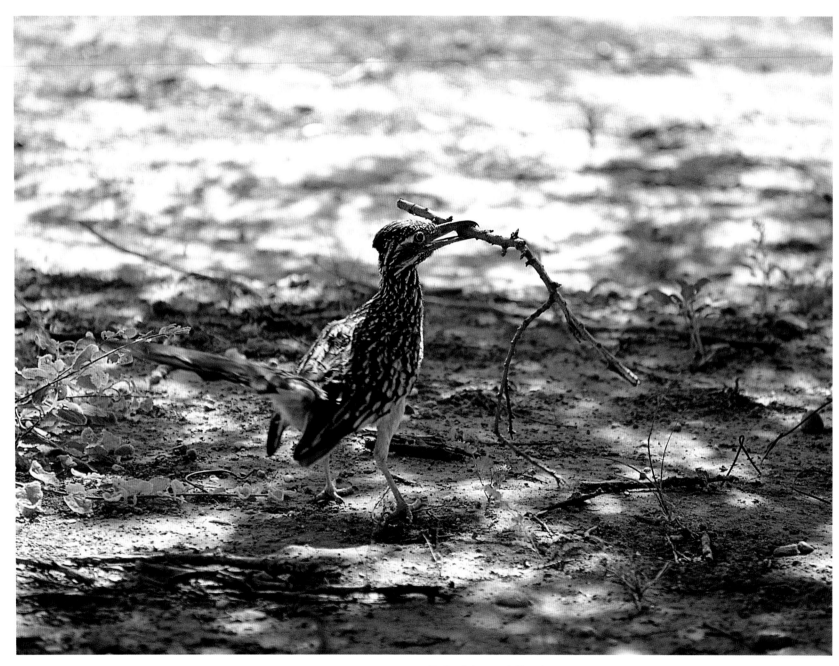

Both adults carefully select twigs and bring them to build their nest.

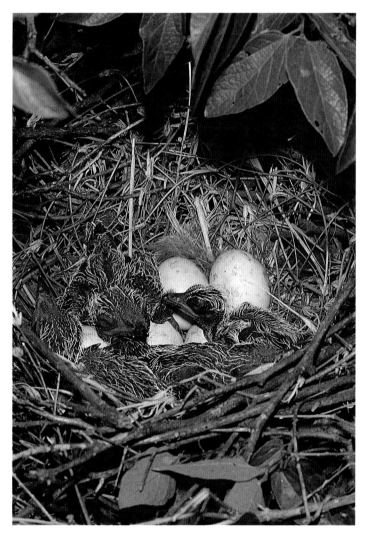

This is the largest clutch that I have ever seen. There were nine eggs laid. This shot shows five eggs remaining to hatch, the four young range in age from two days to one week.

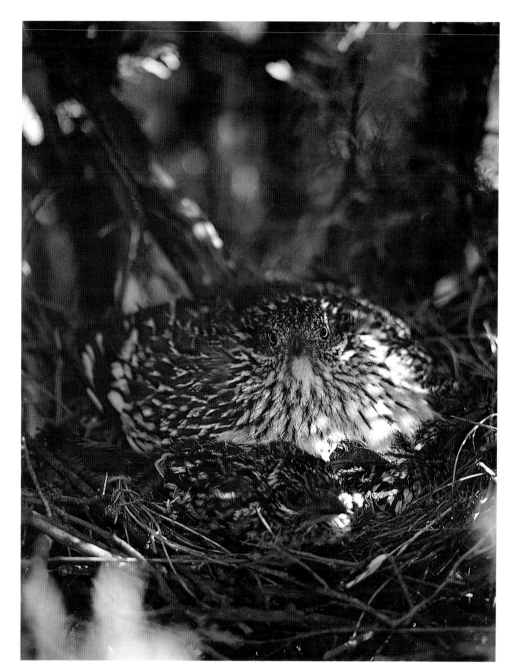

Parent on the nest with young.

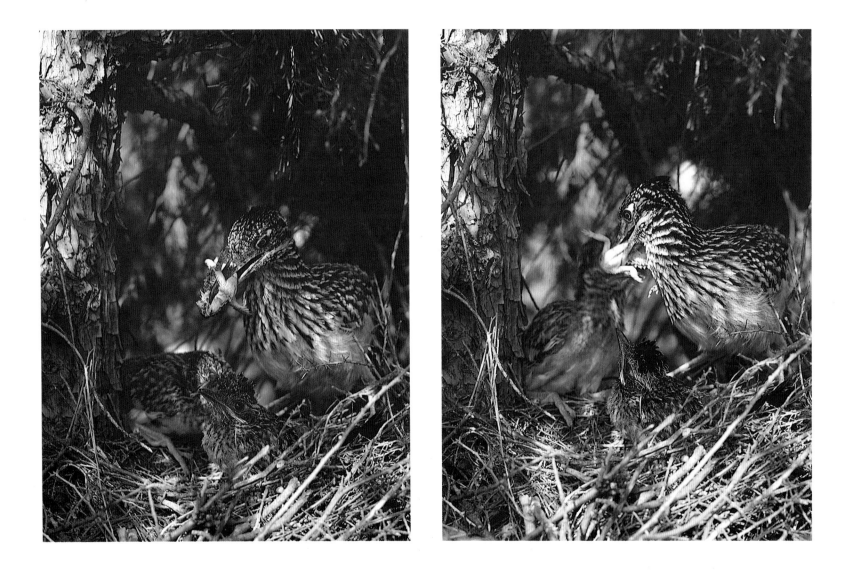

As these tiny roadrunners struggle to swallow horned lizards, the adults stand by and moniter the youngster's progress. If the nestling cannot swallow the prey, the adult gives it to another nestling. If none of the young can manage the meal, the adult eats it.

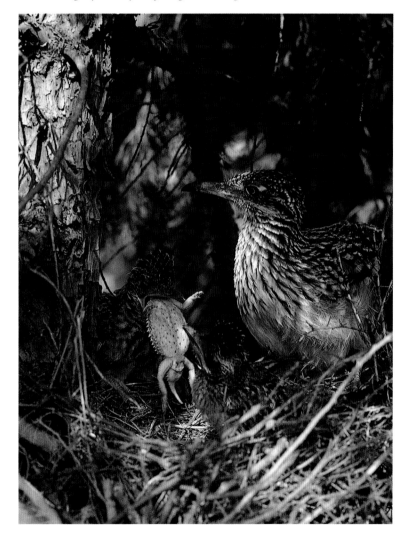

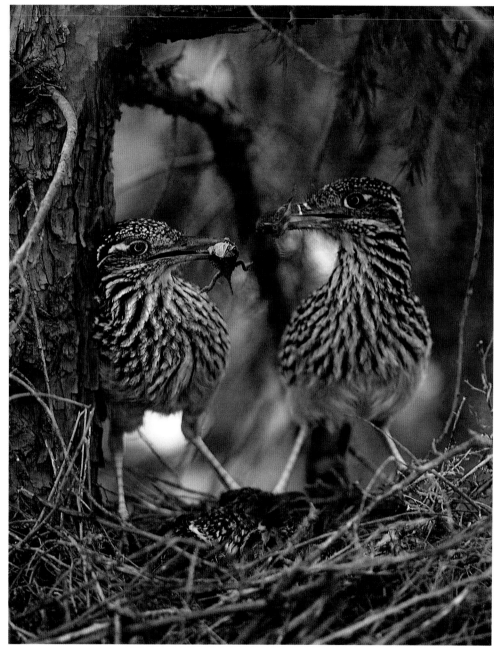

89

At six days of age, the fledglings are brought young horned lizards to eat. It is not unusual for the adults to bring as many as three horned lizards at one time. Roadrunners have a varied diet and tend to select whatever is most abundant as the prey of choice.

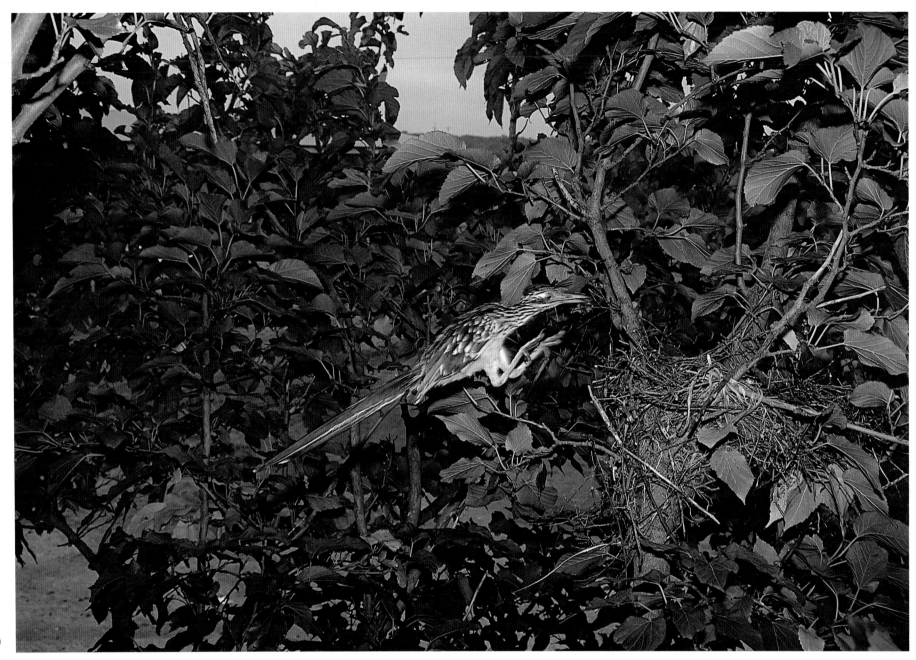

Roadrunners rarely fly to the nest. Instead they have a set of branches they use to jump from limb to limb.

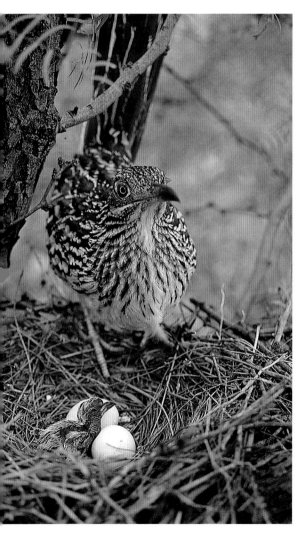

One-day-old chick. This is the last young of the year (late August).

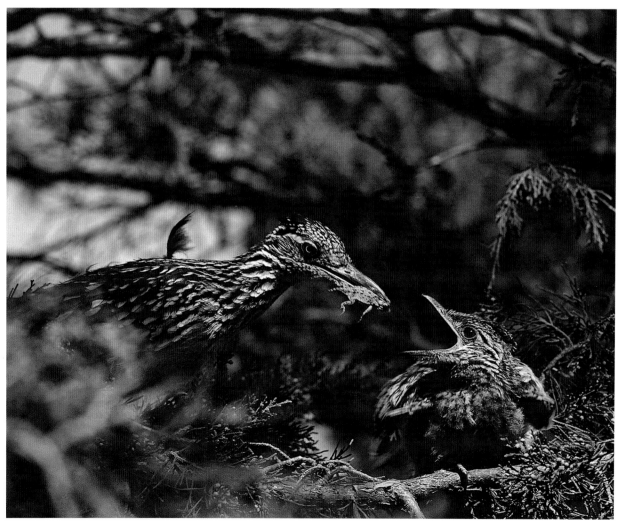

91

An adult feeds a horned lizard to a juvenile that is about ready to leave the nest.

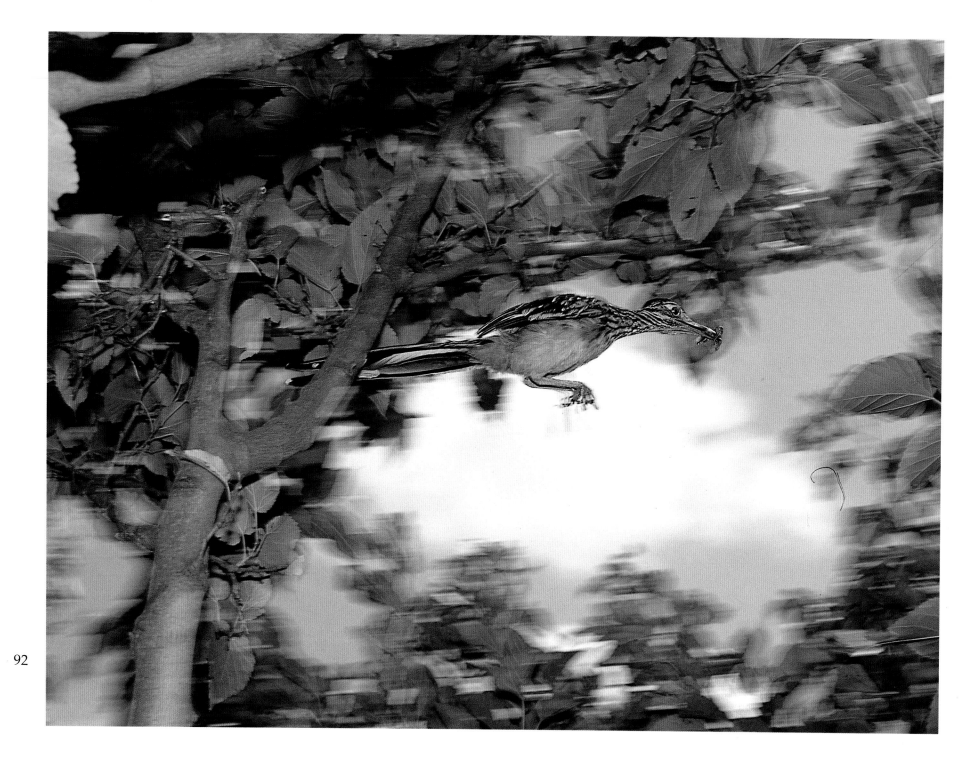

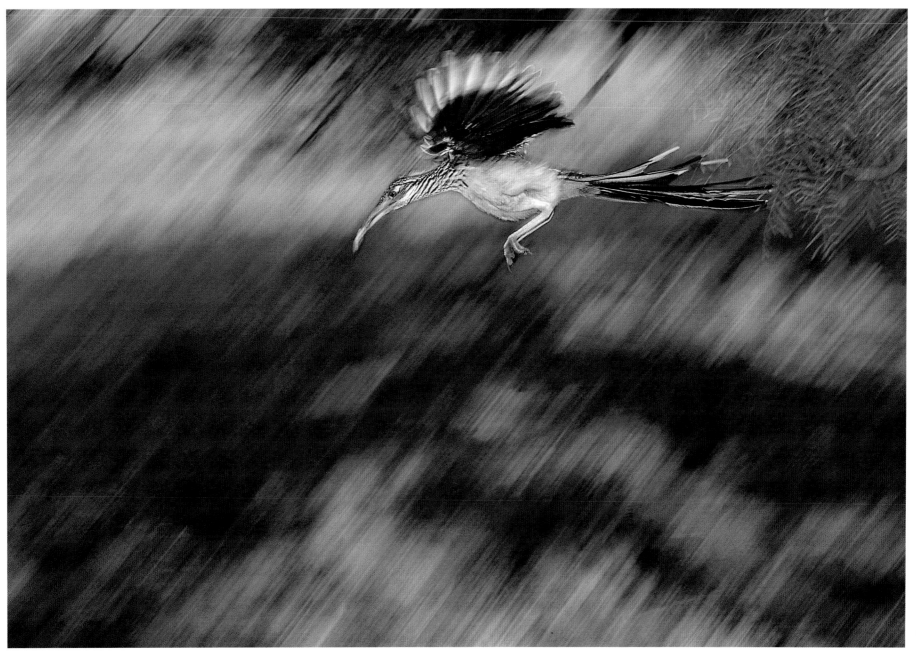

93

To descend from the nest the roadrunner hops out on a limb that has a clear path to open ground and volplanes from the limb to the ground.

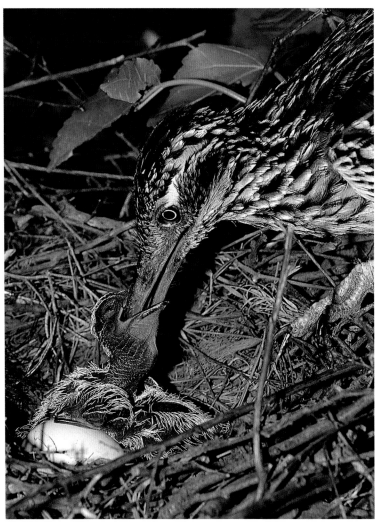

An adult feeding three-day-old young. The eggs hatch sequentially, there is still an unhatched egg in the nest.

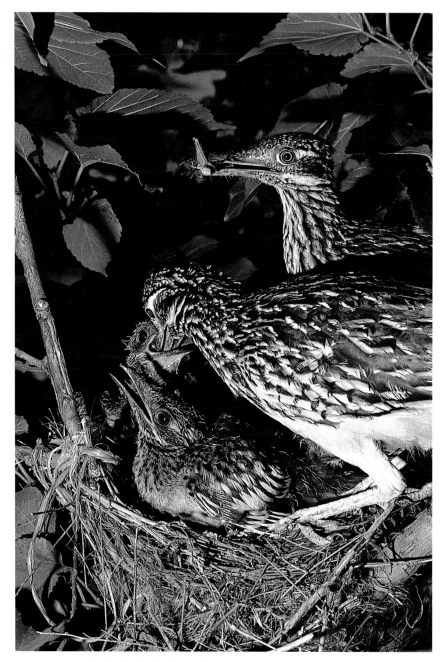

Both adults feed the juveniles. These young are within about one week of leaving the nest.

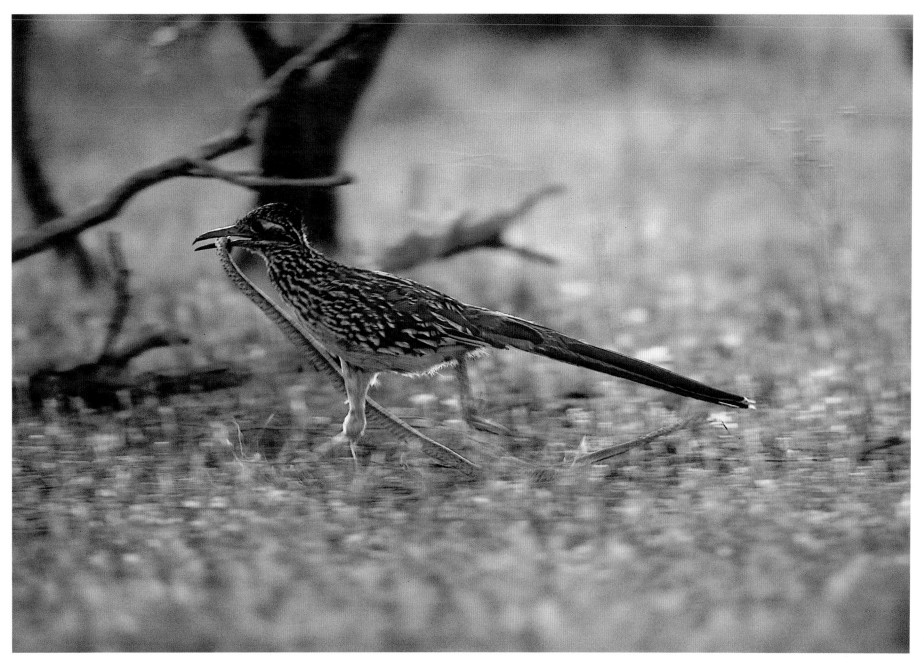

An adult runs to the nest with a garter snake.

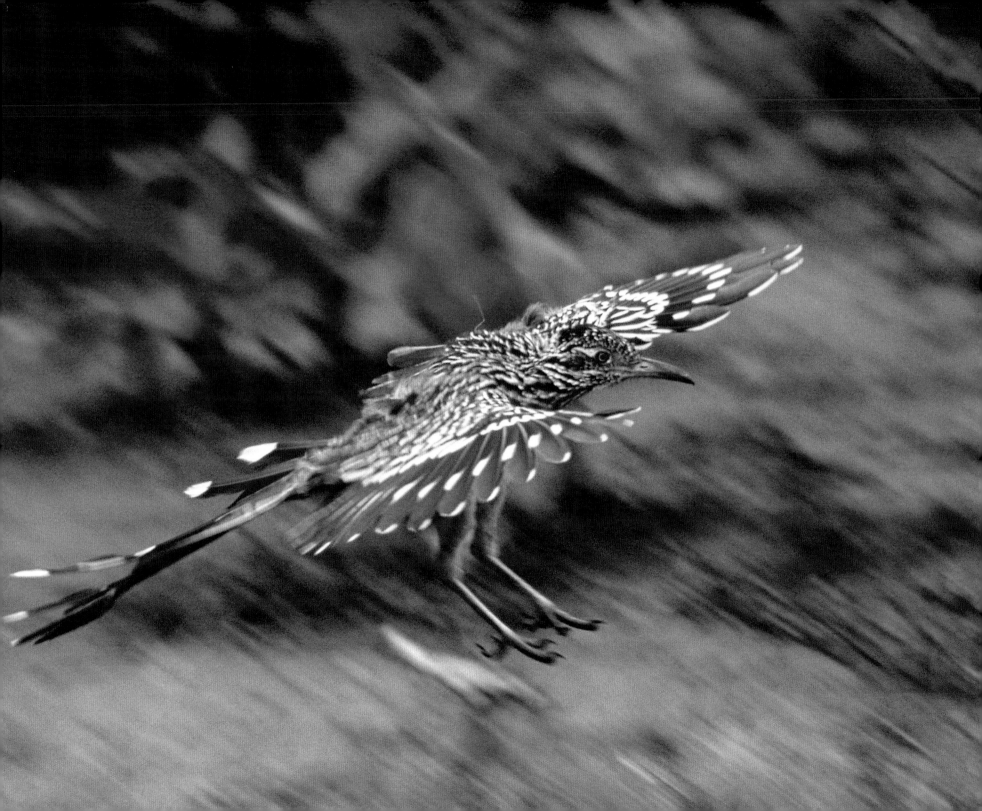

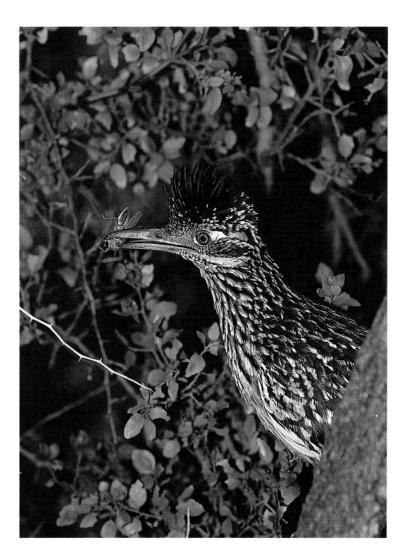

Although their preferred method of travel is walking or running, occasionally roadrunners will fly for short distances.

Before feeding a grasshopper to a juvenile, the adult removes its hind legs. This is the only instance in which an adult prepares a prey item other than crushing it for the young.

97

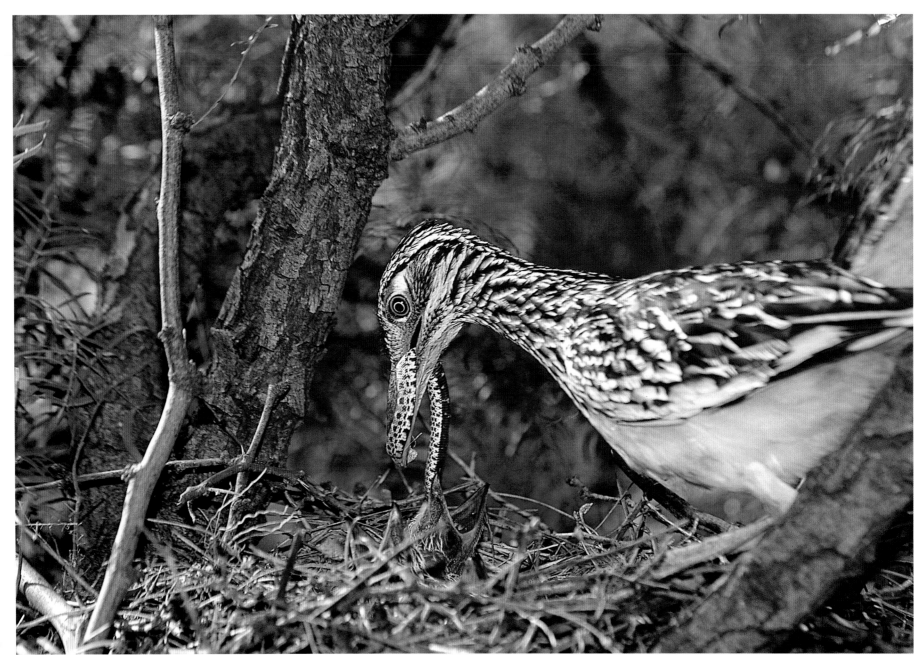

98

An adult feeding a fledgling a hog-nosed snake.

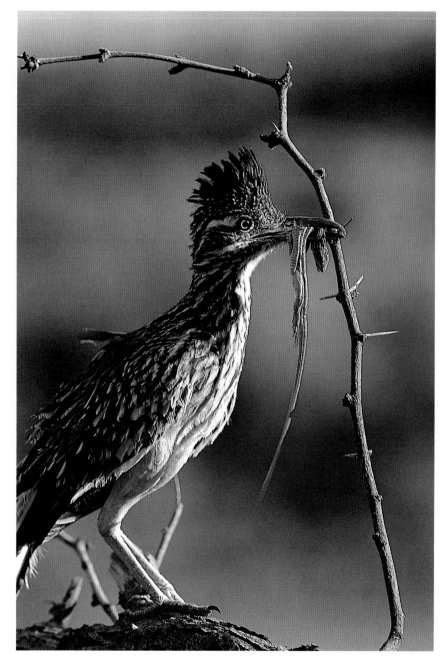

The spotted whiptail lizard is a common prey item for roadrunners.

Chicks are the most vulnerable the first five to seven days after leaving the nest. This one was crushed by a cow. Although adult roadrunners have few natural enemies the young and eggs are prey for raccoons and housecats.

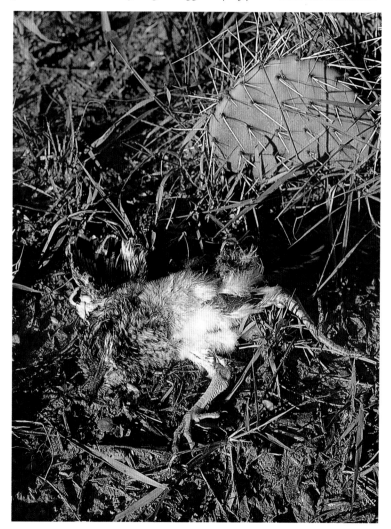

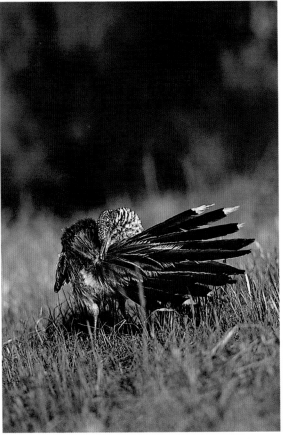

After leaving the nest, the adult often stops in a sunny spot to preen.

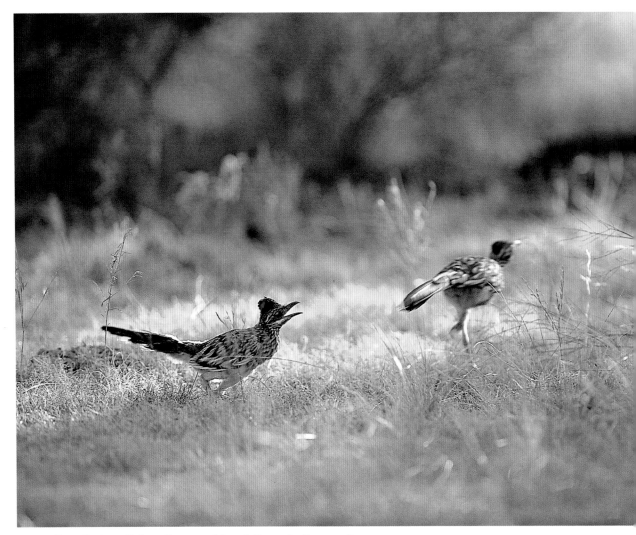

Once the juvenile is on the ground the adults gradually move it away from the nest by enticing it with food. The adults will feed the young for up to ten days after leaving the nest.

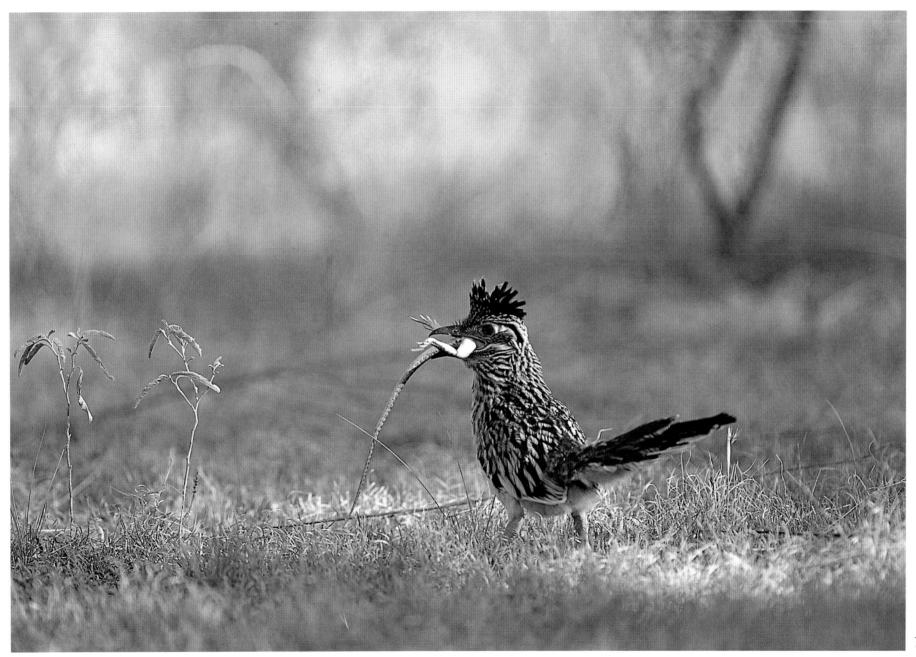

A juvenile roadrunner swallowing a juvenile collared lizard. This was given to it by a parent.

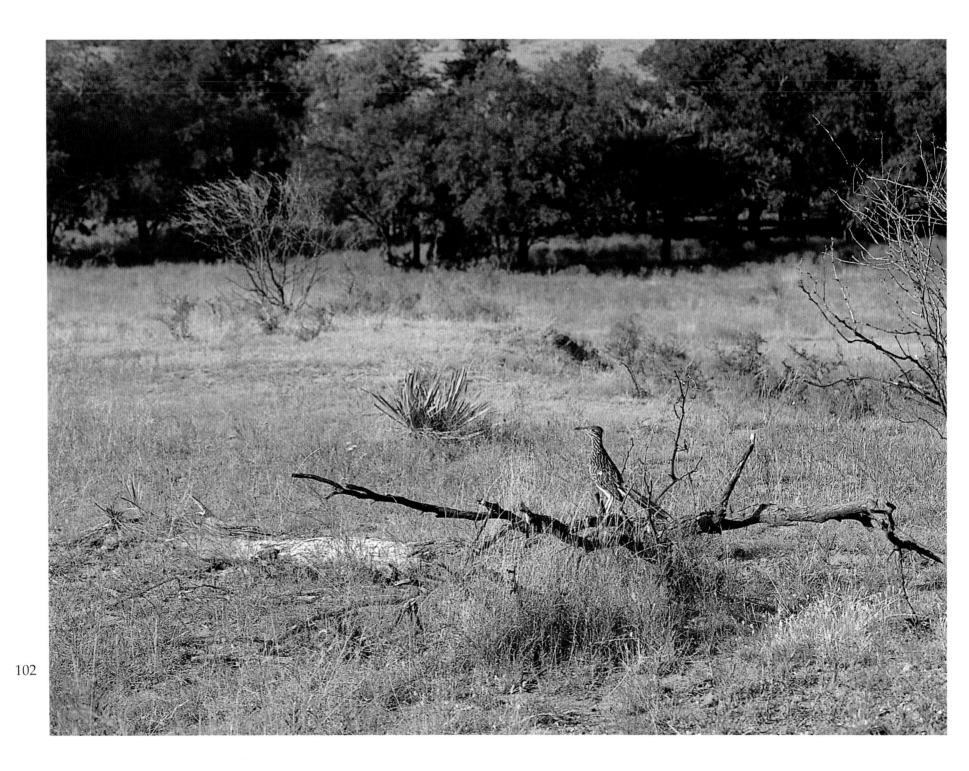

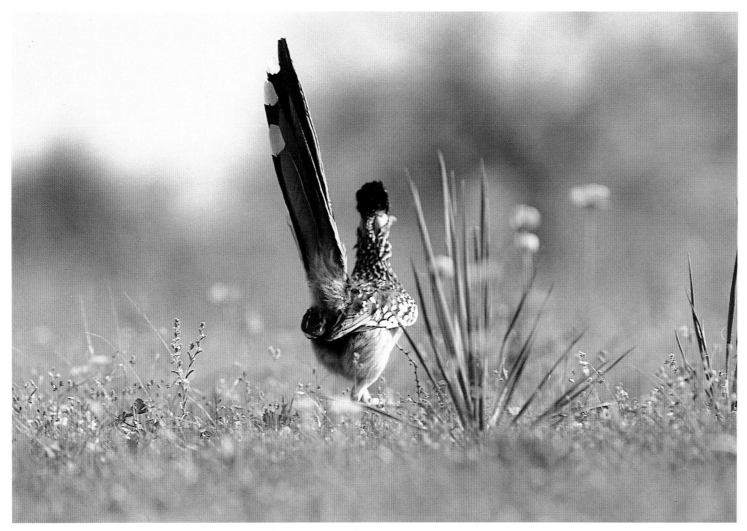

A roadrunners reacts aggressively to a foreign bird entering its territory.

A roadrunner surveys its territory. Most territories of adult pairs in the Rolling Plains are 90,000 square yards.

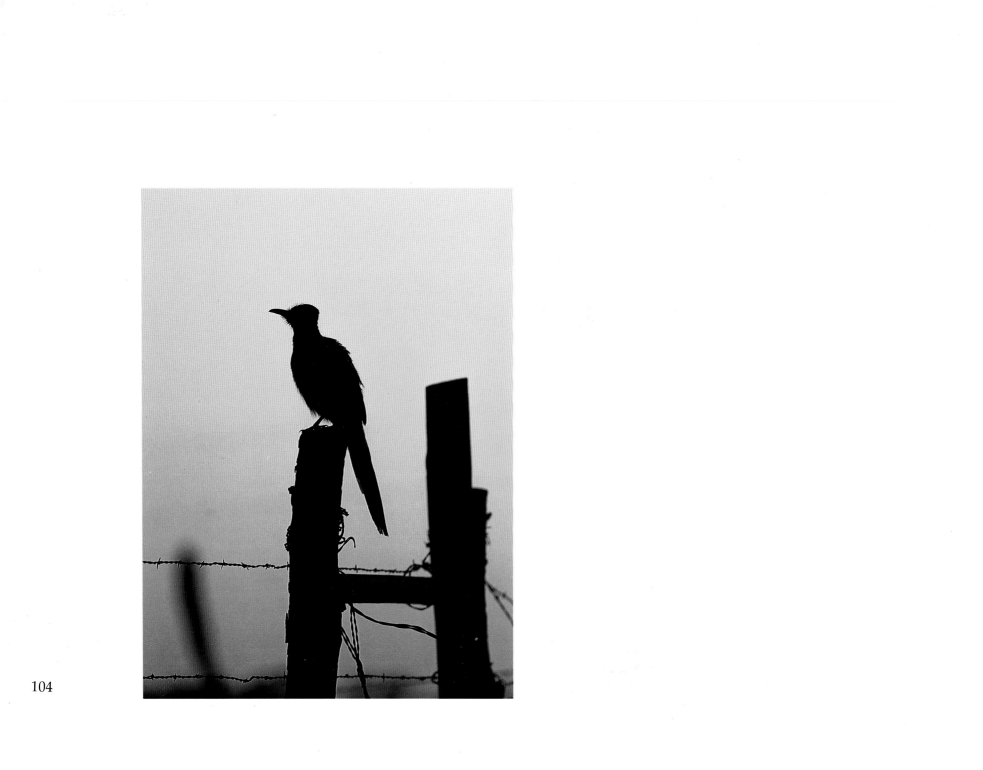